fine art screenprinting

fine art screenprinting

Maggie Jennings

THE CROWOOD PRESS

First published in 2015 by
The Crowood Press Ltd
Ramsbury, Marlborough
Wiltshire SN8 2HR

www.crowood.com

British Library Cataloguing-in-Publication Data
A catalogue record for this book is available from the British Library.

ISBN 978 1 78500 981 0

Frontispiece: Streaked Tulip on Pale Yellow

Acknowledgements
Thanks to Andrew Warrington for photographing almost all of
the book (the photos of the processes and many of the artist
examples). I'd also like to thank him for his help and generosity.
Thanks also to the Heatherley School of Fine Art for kindly allowing
the use of their premises and equipment; to Jeanette Barnes
and Fabienne Khial for their contribution and help in Chapter
9; and to all the contributing artists: Ian Bailey, Sophie Barr,
Nicky Basford, Lynne Blackburn, Martin Burrough, Jaques Cader,
Paul Clark, Marie Coccolatus, Jane Gray, Nicola Green, Chika Ito,
Niall Kirk, Kathryn Maxwell, Stephen Mumberson, Paul Munden,
Penny Mundy, Christina Niederberger, Celia Normand, Sarah Riley,
Ian Scaife, Jane Stothert, Esther Sunyer Parellada, Judith Symons,
Andrew Warrington and Jairo Zaldua. James. C. Gray was the
photographer for Jane Gray's *Morocco1* and *Morocco2*. Philip Gibbs was
the printer for Christina Niederberger's *Chandelier*. Gigi Giannella was
the photographer and Katsura Isobe as the performer depicted in the
imagery of Jairo Zaldua and Nicola Green.

Typeset by Servis Filmsetting Ltd, Stockport, Cheshire
Printed and bound in Malaysia by Times Offset (M) Sdn Bhd

CONTENTS

AN INTRODUCTION TO FINE ART SCREENPRINTING

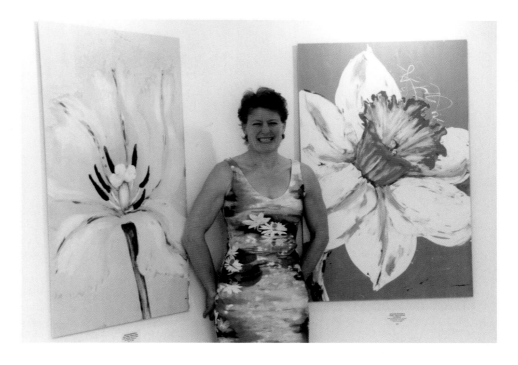

The author with two flower prints. Screenprinting is mostly about colour. It allows you to produce large areas of vibrant colour. These works are 112cm x 71cm.

In this book you will be introduced to the fine art and language of screenprinting. You will be advised how to develop your ideas through this new medium, exploring, with informative illustrations, the many and various ways of creating your print. Printing on paper with water-based inks, you will be guided step by step through the technical processes; having the pitfalls pointed out so you avoid stumbling into them.

- The processes described to create your print include:
- making screenprints with photo-sensitive emulsion in an equipped print room
- making prints from paper stencils
- using direct methods of applying ink to the screen including monoprinting
- full guidance on screenprinting kits for use at home; this also refers to textile home printing.

OPPOSITE PAGE:
Maggie Jennings, *White Poppy*. Rich and vibrant colours with spontaneous free gestural marks.

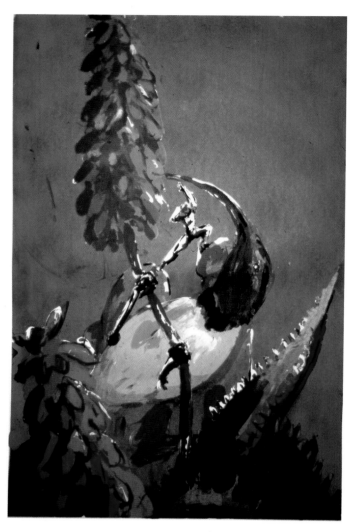

All these colours sing. Jane Gray, *Morocco 2*.

In *SunbirdSips,* the colours are mixed to their full intensity and demonstrate the vibrancy of the screen inks.

In Jane Grey's *Morocco 2*, the rich colours of translucent screenprinting inks are over-printed to create more variation and richness. Screenprinting allows you to use the same stencil over and over again in different places to create the design.

Printmaking techniques can seem mysterious and complicated. There are a series of steps that have to be taken which may involve quite complex mental processes, and decisions to be made that often seem to rely on hope and faith rather than exact certainty. But, after all the calculations and labour, all printmakers will recognize the exquisite magic of seeing their work emerge, maybe not quite as imagined, but satisfying, beautiful and complete.

Kathryn Maxwell's *Diamonds Make Me Smile* encapsulates the playful side of screenprinting. Using blocks of coloured shapes and also drawn lines, negative and positive shapes create a captivating and engaging print.

Sunbird Sips. In this large image 112cm x71cm, the colours are rich and vibrant.

THE LUMINOSITY OF COLOUR

Screenprinting is mostly about colour. It allows you to produce large areas of vibrant colour. Pushing ink through a mesh allows only the thinnest layer of colour to be deposited on the paper. This gives a glorious luminosity. The white of the paper glows through, ensuring colour values remain bright, clean and rich. The print forms a satisfying bond with the paper.

Once the ink is printed, it dries quickly and will not smudge or merge with subsequent layers, giving a clean exact image. Prints seem to have a sense of authority and completeness.

The first photograph here shows the author with some of her work. This demonstrates how screenprinting is a great medium for producing strong, rich colour fields on a large scale. These works are 112cm x 71cm.

MULTIPLES

All print techniques were originally devised to create multiples for commerce. Screenprinting is still used commercially to print large posters and billboards.

Now digital processes are mostly employed for creating multiples, and the older reproductive techniques have been discarded by industry. This is good news for the creative artist who has adopted these printmaking techniques as new vocabularies

After all the preparation, seeing the finished screenprint is so satisfying. Kathryn Maxwell, *Diamonds Make Me Smile*.

to discover and experiment with, providing new structures within which to build ideas.

It is refreshing to be able to create an edition of your work that can be exhibited in many places simultaneously. An individual print will be sold more cheaply than a one-off painting, but, if the whole edition sells, then the artist may be renumerated equally well as if for a painting. Editions of prints also allow for the possibility of contributing to artists' print portfolios. It is so easy to print large editions of screenprints that it can be a rewarding way of making greeting cards or business cards or even illustrating your own books.

PRINTING PROCESSES

Having set functions to perform gives a framework to the working procedure. When involved in the more mundane tasks

the technique requires, the unconscious imagination has the time and freedom to propagate and ferment.

It is possible to produce large editions of identical prints, but also, it is great fun to push the boundaries of print, playing with the techniques to create something new with each work. This way each print differs slightly, making it individual – a one-off. Why not make a series, rather than an edition?

SILK-SCREEN

Originally, the mesh used for printing was made of silk, and the name silk-screen printing is still often used. Silk, though fine and strong, can rip easily, and may sag a little when covered in ink making precise registration difficult. Today, we use synthetic fibres for the mesh, so screen-printing is a better title for what we are doing.

A BRIEF HISTORY OF SCREENPRINTING

Stencilling was used in China as early as 960AD for fabric designs. Intricately cut paper stencils were held together with hair and colour was dabbed through the stencils with soft pads or brushes.

Screenprinting arrived in Western Europe in the late eighteenth century to print fabrics. Silk was stretched over a frame to support a stencil. Ink was forced through the silk with a stiff brush. The magnificently named 'squeegee', the rubber blade which is now used to squeeze the ink through the mesh, was introduced in the early 1900s.

Early in the 1900s, experiments with photo-reactive chemicals started the photographic processes we use today. Then artists experimenting in New York in the 1930s wanted to distinguish fine art work from commercial design. They introduced the name 'serigraphy' which is used in America to distinguish their art from the manufacturing process.

In the 1960s screenprinting came into focus in the art world through Pop Art. Artists such as Warhol, Paolozzi, Hamilton, Rauschenberg, Lichtenstein embraced the idea that they were using a commercial process usually employed for creating ephemera. They made a focus of the fact that the images could be made in their thousands and, because of this, could equally be trashed. Bright, synthetic coloured inks with no intention of longevity were employed. Art was about disposability. Art was everywhere, and it was accessible to everyone.

Ironically, most of those screenprints now sell for top prices, accessible only to the wealthy art collector.

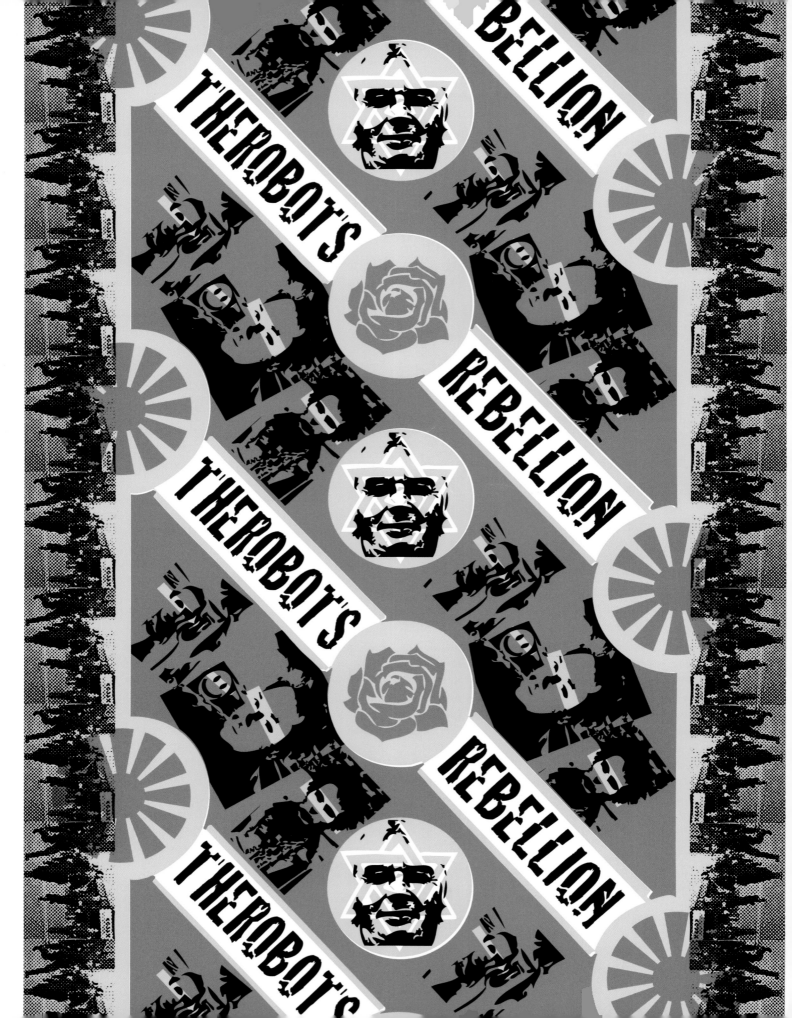

AN INTRODUCTION TO THE PRINT ROOM

This chapter is an introduction to the equipment and materials you will find in the printmaking studio.

It is very important to know what everything does, where everything belongs, how to treat and care for things and how to take care of yourself in the print room. The hardest job by far is to keep things clean. Many a fantastic print ends up with grubby marks, splashes and fingerprints around it. It is easy to get in a terrible smeary mess very quickly. Be as organized as possible, especially in a shared print room.

Be sure you are aware of where to put things – the designated clean and dirty areas. There should be a separate clean area for preparing paper. Keep your paper in a plan chest drawer or bring in your own folio for storage. Keep to the separate areas for mixing inks and storing inky jars.

Collect old cotton rags; always have clean rags handy, one of the most precious pieces of equipment in the print room is a clean, dry, cotton rag. Wear an old shirt or an apron, one with pockets in which to keep that precious rag is invaluable. It may be worth buying your own rubber or latex gloves and keep them handy in your apron pocket.

When a busy print room is in full swing it can be quite hard to find places to put things. Keep your own belongings together in a bag that can be placed out of the way. It may be worth investing in a work box for your own drawing materials and paints. This can be stowed under the work tables.

These days, we use very few dangerous chemicals. A general rule is always to use rubber or latex gloves when handling any substance. If you have an accident, spilling anything on yourself, copious quantities of water is usually the best first step. Check out where the First Aid box is kept. There is usually an eye-wash station for splashes in the eye.

Although much care is taken these days to use only safe ingredients, many paints are made from poisonous substances. It is a general rule that food and drink are never taken into a print room. Remember to wash your hands before eating. Try not to dip your brush in your coffee mug.

EQUIPMENT YOU SHOULD BRING

An artist should always carry a kit of the necessary art equipment. Get used to having a pencil case that always contains the basic set of tools. This should include *pencils*, preferably HB or B, for drawing your ideas, for making registration marks on the print to be erased later, and for signing the finished print. If you like a fine point on your pencil you may like to get a propelling pencil. Lead in-fills of all different grades can be bought in a good art equipment shop.

Don't use a hard pencil for making registration marks, for example 2H or even higher values up to 6H. Although they can be sharpened well to give a wonderfully exact point, which is attractive for precise registration, they can incise into the printing paper and be impossible to completely erase later.

A soft *eraser* is necessary for erasing registration marks on your printing paper. It might be a good idea to have a hard eraser too for tackling stray ink marks and splashes on the borders of the print when the ink is dry.

Always have a sharp *craft knife* or *scalpel*; this is absolutely

OPPOSITE PAGE:
Ian Bailey, *Rebellion 1*. A mix of photographic imagery, simple shapes, text and strong colour demonstrate screenprinting characteristics.

essential if you plan to cut stencils. Hopefully the studio will have a cutting mat. If not, lay down layers of newspaper to protect table tops from scoring. Also *Scissors* are always invaluable. Gnawing off lengths of plastic tape with teeth is never the most efficient method.

A *ruler* is essential. The print room should have a long heavy rule for tearing paper. When using this, always check that it is clean before putting it down on your lovely clean printing paper. Keep your own ruler or *tape measure* for working out border widths and so on.

Buy a *brush roll* for transporting your *brushes* without damaging them. You may need both watercolour brushes for working in your sketch book and harder hogs-hair brushes for use in monoprinting.

Your own roll of *masking tape* is handy. You often need it urgently to fix a printing problem or for registration, and you don't want to have to roam around the printroom searching for the communal roll. You can keep it handy on your wrist, 'the printmaker's bangle'.

Pens – for drawing or taking notes and *marker pens,* which can be very helpful in working out the colour layers in your design in your sketchbook. Always have with you a *work/sketchbook* containing all your ideas and with plenty of room for working out processes.

THE WASH-OUT ROOM

Use gloves for all these chemicals.
Chemicals used:

* Degreaser (this may well be general washing-up liquid)
* Photographic emulsion (kept in the fridge)
* Stencil remover (slightly caustic)
* Heavy duty bathroom cleaner
* Alkaline cleaning paste (this is highly caustic, and to be used only with protective wear)
* High pressure water blitz/power blaster.

To use the water power blaster, check that the water source is turned on, then turn on the switch at the machine. Wear a waterproof apron, earmuffs and goggles when blasting.

SCREEN VACUUM BEDS

Vacuum beds have small holes drilled in the bed surface and are attached to a vacuum pump.

The vacuum holds the printing paper onto the screen bed. This will keep the paper in the correct position for printing and also prevent it from sticking to the screen and leaving a tide mark as it pulls away. It will have been adjusted to switch off as the screen is raised, making paper placing possible. Try lifting the screen and you will hear the vacuum turn off, then on again as you lower it. The vacuum can make a lot of noise, which can

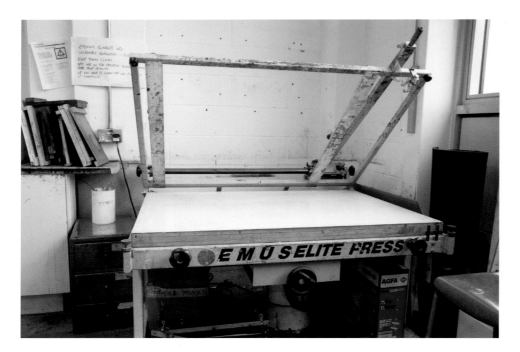

Vacuum bed.

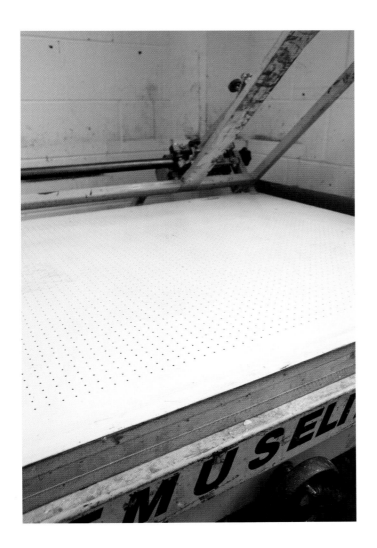

Small holes drilled in the bed surface for the vacuum.

be annoying. Some people prefer not to use the vacuum for added peace.

TABLE-TOP SCREENPRINTING

It is possible to print without using a vacuum. Screens for printing can be attached to a table top with a hinge. Hinges, that secure the screen to a table top or board, are available from printmaking suppliers. The ones shown were made by the studio technician.

Make sure the hinges are firmly secured as, when printing, it is possible to knock the screen out of true if it is not well fixed and that would give registration problems.

See Chapter 9, Screenprinting Kit, for home printing without a vacuum bed.

THE SCREEN

The screens are made of polyester, which is less likely to rip than the original silk, but care still needs to be taken. Don't lean it against sharp corners. If you notice a small hole or the beginning of a tear, protect that area with plastic parcel tape. Small holes in the printing area are not usually noticeable in a busy print.

The hinges can be screwed onto a table top or a board. These hinges were made by Joe Hanson from a design by Philip Gibbs.

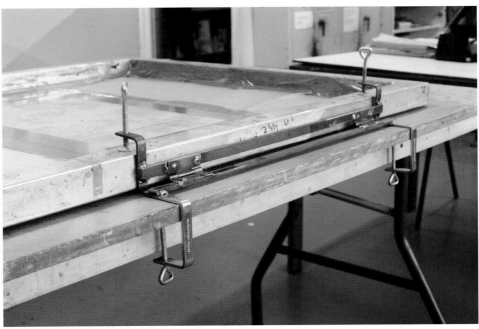

Ensure the hinges are firmly screwed down so the screen doesn't slip.

Screens are made of polyester mesh.

MESH PROPERTIES

Mesh at 45 would have only 45 openings per cm and let through a thicker layer of ink. This size would be good for fabric printing and printing on rough paper. You might be able to see the square edges of the holes. 200 mesh lets through a very fine layer. This is good for printing fine type, but is harder to manage as ink dries very quickly in the screen.

Yellow mesh is usually used in print rooms as it accepts the developing light better. White mesh is preferable if you do much monoprinting so you can get a better judge of colour. Completely new mesh will need to be degreased and roughed up a little with a scouring powder.

The mesh comes in different sizes marked with numbers which denote the amount of openings per centimetre in the weave of the mesh. For example, mesh size 120 has 120 holes per cm, and is a good general size mesh. You can use anything from 75 up to 200 mesh.

SQUEEGEE

This is the wonderfully named rubber blade, in a wooden or aluminium handle, used for pushing the ink through the mesh. You will need different length squeegees for different sized images; it needs to be about 2cm wider on each side than your image. Take care of the squeegee. The blade should have a

The wonderfully named squeegee.

Squeegee rack. Use a squeegee that is about 4cm wider than your image.

Squeegee edge. Take care with the squeegee. Make sure not to nick the edge or you will get a noticeable line of uneven ink through your print.

sharp edge with no nicks in it. Any imperfections will result in a noticeable line or uneven ink throughout your print.

A squeegee rack will ensure that the squeegees are not damaged when not in use. A damaged edge can ruin a print.

Save old jars with lids to store inks.

INK MIXING AREA

You need a designated area for mixing inks.

Here is where you keep the screen medium and your stock of paints. Collect old jars with tops for mixing and storing. These could be jam jars, or yoghurt pots with well-fitting lids. Inks kept in airtight containers can last for months.

Don't get confused as to what is just acrylic paint and what is a mixed ink. The paint will be in its shop bought pot or tube. The mixed inks will be in one of the jars or pots brought in by you. So, to distinguish paint from ink; anything that is in a jar has already been made into an ink.

Palette Knives

Use plastic or, preferably, superior polythene palette knives rather than metal. Sharp metal palette knives designed for painting could slash your screen mesh. Plastic or polythene palette knives are also excellent when monoprinting for applying the ink as thinly as required into the mesh.

Collect old plastic credit or membership cards, they are great for scooping the ink back into your jar after printing, they are almost purpose designed with rounded corners to avoid inadvertently slashing the mesh. Pieces of card cut to handy sizes will do too.

Acetate

You will need a sheet of acetate for registration, Make sure it is large enough to cover the printing paper. It can be bought at art and graphic equipment stores.

Tape

Plastic parcel tape will seal your screen.

Don't leave plastic parcel tape on your screen for too long. Remove it after the job is finished. If it is left on for a few months, the glue can harden into the mesh and be difficult to remove. Masking tape is useful for fixing a registration sheet

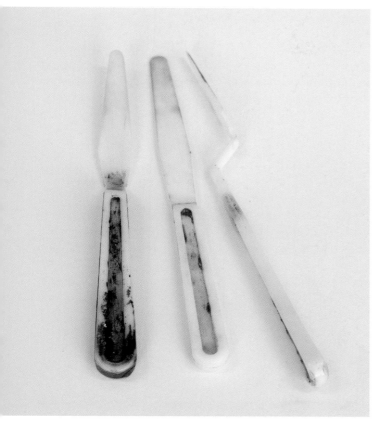

Polythene and plastic knives will not slash the mesh.

Tape: plastic parcel tape will seal your screen. Masking tape is useful for fixing registration sheet onto the screen bed and making registration marks.

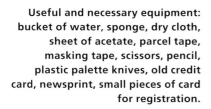

Useful and necessary equipment: bucket of water, sponge, dry cloth, sheet of acetate, parcel tape, masking tape, scissors, pencil, plastic palette knives, old credit card, newsprint, small pieces of card for registration.

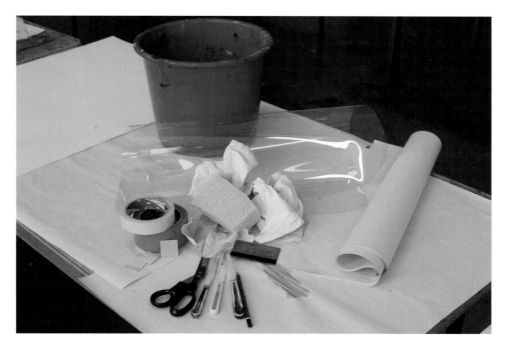

onto the screen bed and making registration marks. It can also be a quick fix for covering up holes that appear in the borders or areas of stencil while printing, but it is a little thick and, ideally, shouldn't be used too close to your printing area.

Newsprint and Newspaper

Make sure you have an adequate supply of invaluable 'newsprint'. This is the name of the paper that newspapers are printed on. It is cheap, smooth and nicely absorbent, making it a printmaker's best friend. Always have several sheets at hand, when you spot a mistake where ink has bled or broken through, print the next few prints on newsprint until the image clears.

You also need quantities of old newspapers, that is, the ones you read and throw away daily; they are essential for cleaning up.

THE DARKROOM

Most print rooms will have a darkroom with a safety light. However, the emulsion is not that sensitive; if necessary, you can just use a dark corner to apply the emulsion, as long as there is a really dark area with a fan drier to dry the emulsion.

EXPOSURE UNIT

The unit will have its own directions for use.

This is where your image gets transferred onto the screen mesh. The ultraviolet lights are at the bottom. There will also be an ordinary light for positioning the image, so you can also use the unit as a light box. This is great for checking that the positive is opaque enough. On the console besides the power switch will be a vacuum switch and a timer. Hopefully, the exposure times will have been worked out for the unit, they will differ slightly depending on the make up of your positive.

Exposure unit. The exposure unit can also be used as a light box.

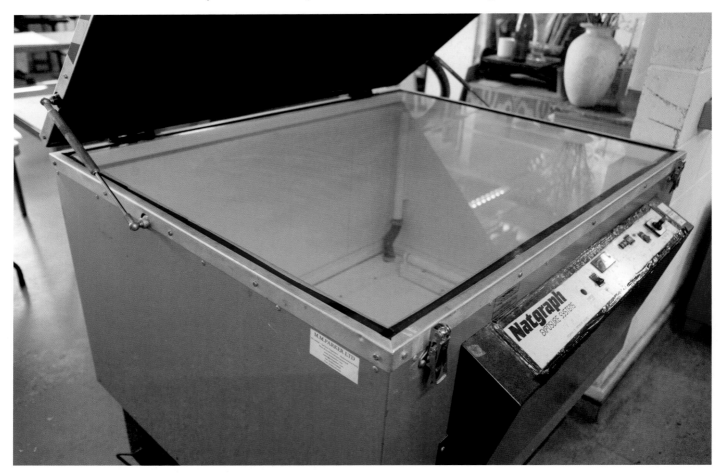

Shorter exposure times are needed for delicate marks. The light hardens the photographic emulsion. Where the screen emulsion is protected by the positive, it remains soft, allowing it to be washed off in water.

PROTECT YOUR EYES

Ultra-violet lights can damage your retina. Never look into the light source. Modern exposure units will have a safety feature to protect you from the light.

PRINT DRYING RACK

There will most likely be a spring-loaded rack for drying prints. These hold a great many works and are invaluable for taking the wet prints while printing. It is a good idea to clear the rack before the start of printing, then use it from the bottom shelf and work upwards. Take care not to bang the spring-loaded shelves up or down as the prints may move or slide down the back.

If there is no rack, check where to put the wet prints before you start printing, they will need to be spread out, not touching each other until they dry, which will probably take about fifteen minutes. An easy-to-make drying rack can be fashioned from a string line and clothes pegs. Hang your prints up to dry like your weekly wash.

Printing Paper

Printing paper is discussed in Chapter 7.

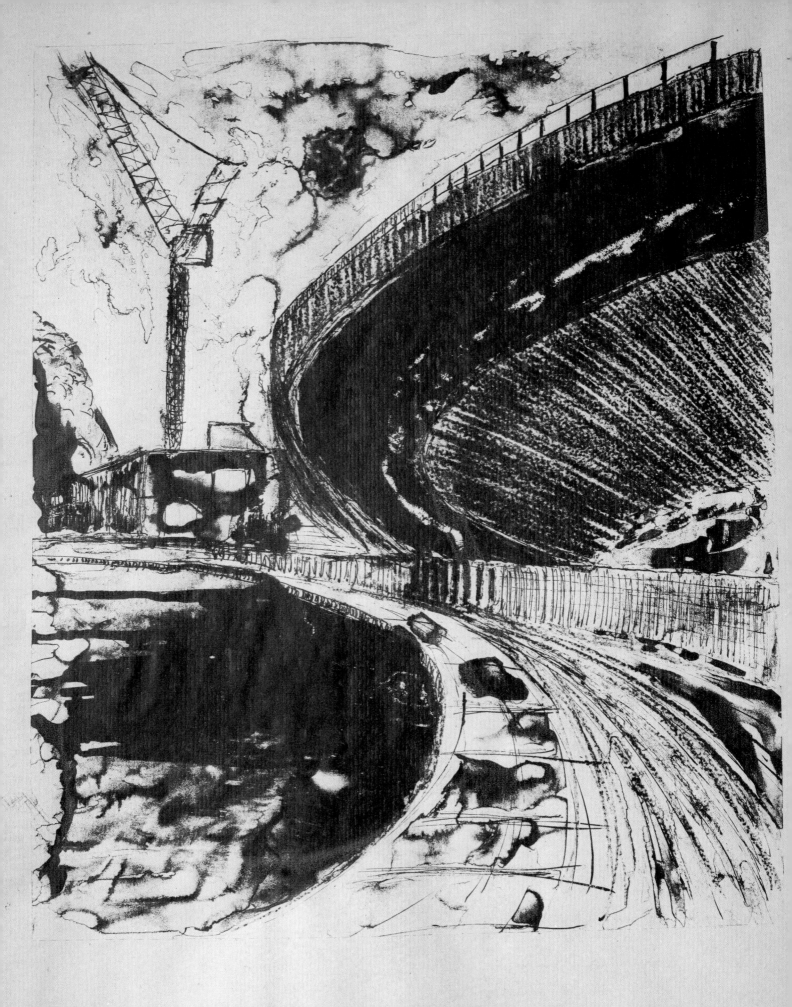

UNDERSTANDING AND CREATING THE DESIGN

This image is made of colour fields, no lines have been drawn. Jane Stothert, *Dorney Lake*.

Printmaking could be thought of as a way of distilling your ideas. There are a series of technical tasks to perform and a finite number of positives to be printed. When painting on canvas there is the opportunity of constantly re-working the image, adding layers of paint, changing the composition as you go. But printing on paper means you must make more decisions upfront, simplifying and distilling what it is you wish to make.

OPPOSITE PAGE:
Andrew Warrington, *Under the Motorway*. Floating Indian ink on water, wax crayon was also used which bleeds into the ink wash. Printed on brown wrapping paper.

Devising a print involves thinking in convoluted steps, sometimes a step ahead or a step behind yourself, sometimes in positive, sometimes in negative. Be patient with yourself. The first print is a steep learning curve. Until you've actually printed something, you cannot really understand how your ideas will manifest themselves, nor can you predict the pitfalls and limitations. So, while following these guidelines, which try to prevent you from suffering the common snags, be prepared take a willing leap into the unknown. Embrace the 'magic of print'. What you might think of as a mistake might end up being a fantastic element in the finished design.

Take time working out the image. Use your work book to

design the stages and layers. Be prepared to be a bit flexible and possibly change the design as you work through the various stages, you might need to revise or change ideas mid-print.

Screenprinting is more about colour fields than line. The edges of the colour field can give you the line.

In Jane Stothert's image *Dorney Lake* the image is made of colour fields, no lines have been drawn. Each colour sits as one layer on the white paper ensuring a clear bright colour. The shapes have been elegantly simplified to the bare essentials.

DECIDING THE SCALE AND SIZE

One of the first decisions you have to make is the practical matter of scale. This is governed by the size of screen you have available.

You must allow for a border on the mesh of at least 5cm – you can't print right up to the edge of the screen. It is also a cunning idea to check what size squeegees are available, then plan your image to be about 4cm smaller. Review personal strength and energy. It is hard work printing a large screen by hand, especially if you have to stretch right across the screen to print.

Large areas of colour are exciting, and are what screenprinting is designed for. Unfortunately, a large colour field is the hardest thing to print, with many possibilities for technical mistakes. Don't strain or even do your back in by trying to lean across and apply pressure at too far a reach. So, just for your first ever print, curb your ambitions a little and try a small-scale image, no larger than A3. Many print studios use screens that fit two A3 size images side by side.

If you have access to a screen bed that has a fixed squeegee arm, you can print larger images more easily, but I would suggest doing the first print by hand so you understand the process.

PROBLEMS WITH PRINTING LARGE COLOUR FIELDS

Plan that giant print on the extra large screen for after you have accomplished the first print. Printing a large colour field presents many possibilities for errors. With a large area of ink the mesh can dry very quickly, even between pulling each print, causing ink to harden in the mesh. This needs cleaning immediately. You will see white specks or areas in the print where the ink has dried in the mesh.

Large fields of ink can cause the printing paper to stick to the screen. When the paper drops, or is peeled off, there will be a visible tidemark in the colour field. This is even more noticeable when using transparent colours. The print needs to be pulled correctly several times on to a sheet of newsprint until all imperfections are cleared up.

It may be hard to get the correct pressure across a large area. This may result in thick, indistinct edges to the print, or noticeably thick ink in areas across the image.

It is easy to run out of ink while pulling the print. Then several prints will have to be pulled on newsprint to clear imperfections. By now you may have run out of your supply of ink altogether and possibly run out of steam and enthusiasm for the whole project.

It is hard work printing a large screen by hand, especially if you have to stretch right across the screen to print.

DIVIDING UP YOUR DESIGN INTO POSITIVES

Work out the design in colour, separating the colours out. Designers' marker pens can be a good tool for sketching shapes and colour fields. Think of the colours here as merely a guide. You can change your mind in response to the emerging print.

Having spent time planning your image, you should now have a 'master' drawing. This is the complete image as you intend it to appear. It is worth producing it at the scale you want to print it as it will be a helpful guide for placing your images on the printing paper later.

Using sketches or diagrams if necessary, divide up your print into separate colours, a separate diagram or drawing for each colour you intend to make. You need one positive for each different colour.

You may have to think backwards, the first colour is quite often what we would think of as a background, a simple colour

A black paper rectangle may be the first positive.

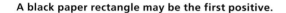

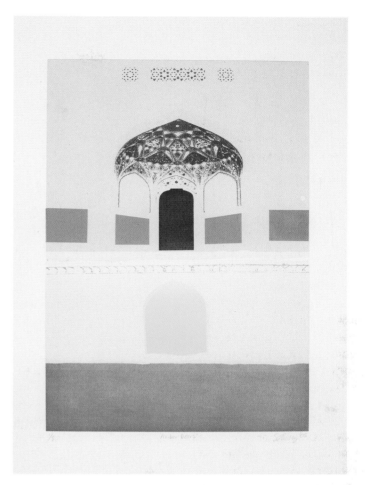

Sarah Riley, *Amber Doors*. Fields of colour pulled through a large open rectangle form the background. Cut black paper shapes of different sizes form elements of the design. Photocopies provide the architectural detail.

field, yet it is best printed first. So your first stencil could be a black paper shape cut to the size of your image. If you prefer a soft edge, tear the black paper shape against the edge of a ruler.

Maybe your second positive is a photocopy. Perhaps your third is something you draw or paint onto some grained drafting film. Any combination of techniques can be used to create the positives Look at your image and work out how many different positives you will need.

In *Amber Doors* by Sarah Riley, a well-thought out and constructed image, fields of transparent colour have been pulled through a large open rectangle to form the background. So positive number one was a large open rectangle on the mesh masked off with newsprint. Positive number two was made from black paper shapes cut to different sizes to form the basic architectural elements of the doors and windows or alcoves. Photocopies provide positive number three that gives the architectural detail.

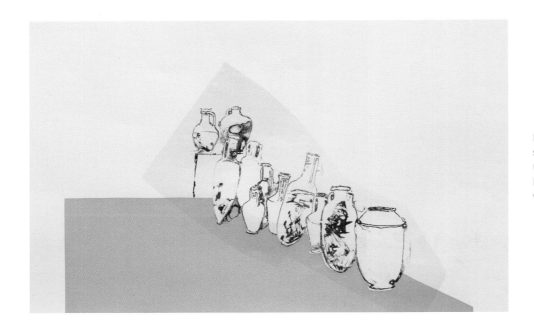

Marie Coccolatus, *Amphoras.* A simple and elegant composition made from three positives: two cut paper shapes and an ink drawing on grained drafting film.

PLANNING THE LAYERS

The luminosity of the colours depends on the paper shining through. The truest colour will be a single layer of ink on the white printing paper. Too many overlaid layers may appear heavy and dull. Limit yourself to five or six colours/layers if they are to be printed over each other. An exciting image can be created with using only two or three layers/positives. Keeping it streamlined and direct can produce a strong satisfying result.

The *Amphora* print, by Marie Coccolatus is a simple, well-planned and elegant composition formed from three positives: two cut paper shapes and an ink drawing on grained drafting film. If you are a bit creative with the colour application a simple layer can look rich and complex as described in Chapter 8, Monoprinting, where several colours are applied through one stencil.

Stephen Mumberson's *Brixton* is a streamlined and direct image, with clever use of negative and positive space. It champions the bold luminous quality of screenprinting. The fairly abstract shapes on the face make up the features, while the actual face itself is unprinted paper. All the colours are bright and luminous as they are printed directly on the white paper.

If you really want to, just go wild and print as many layers as you fancy, that's part of the fun of screenprinting. Though, remember, it's a good idea to try and design the print so that the inks print as one layer on the white paper in order to keep the freshness of colour.

Martin Burrough used many layers from photocopy positives to make this a jubilant image. Each different colour comes from a different photocopy that was used to make each positive. He played with the contrast on the photocopy machine to get

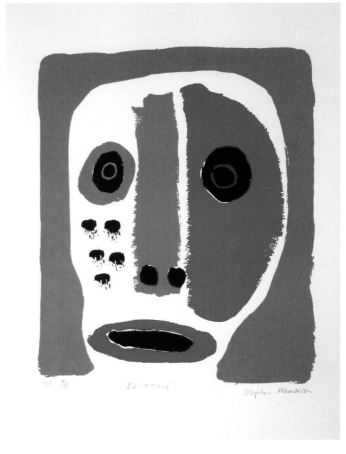

Stephen Mumberson's, *Brixton.* A streamlined and direct image, with clever use of negative and positive space.

Many layers from photocopy positives make this a jubilant image. By Martin Burrough.

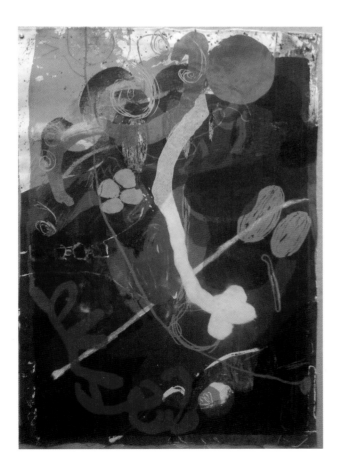

Several layers of deep-hued colour give this print a mysterious richness, especially when contrasted with the strong yellow. By Judith Symons.

In this two-layer print by Paul Clark, white, the most opaque ink, is printed over the blue.

different tonal densities. See how he embraced the photocopy mistakes of blurry excess ink deposits. This is a print that enjoys the positive, and what might be thought of as negative, qualities of printmaking.

Printing layers on top of each other can give a mysterious deep-hued richness too. As a painter, Judith Symons overprinted colours, using the layers like paint and composing the shapes and areas as she worked.

Often lighter tone colours are printed first, ending in dark tones, or black. But white ink can be very opaque. White, and colours mixed with white, can be printed at the end. As shown in this simple, humourous image, devised from two pieces of paper: a black rectangle and a page torn from a notebook. First the rectangle was printed in blue. Next, the notepaper was printed on top in white. Paring back has produced the best impact.

On the whole, these inks are fairly translucent so can change the hue when printed over each other. Plan this into your design. Remember that the brightest colour will be a single layer printed on white paper

When planning colours, don't be too literal. Be aware that colour doesn't act the way you expect when printed in layers. The printed layer is very thin, so the colour in the jar may appear different when it is printed. You really can't tell until you do it. That's why you have lots of extra paper to practise on. Be adventurous and choose colours that surprise you.

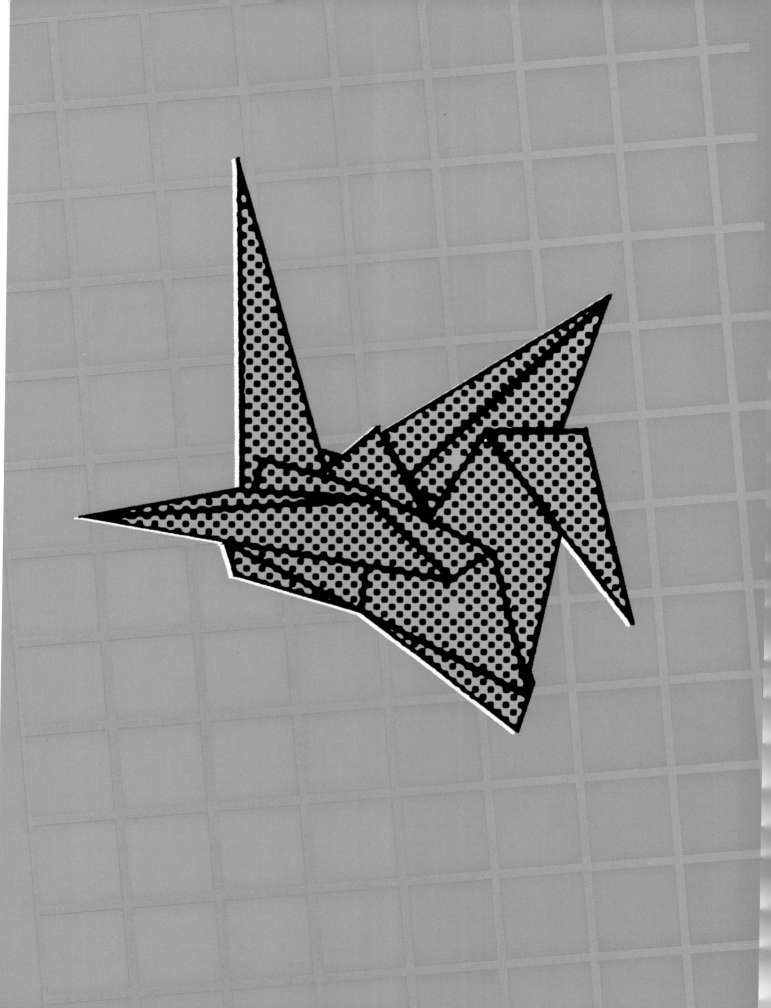

MAKING A POSITIVE

HOW THE PHOTOGRAPHIC METHOD WORKS

The screen is coated with a photo-sensitive emulsion that hardens on exposure to light. The single function of the positive is that it must block out the light. After exposure, the unhardened emulsion will wash away with water leaving an open area of mesh through which you push your coloured inks. This is called a stencil.

This is one of the most important parts of the whole process, where you create your image. Expand your mark-making vocabulary. Each positive can be created in different ways giving maximum variations of marks. The main point being, that the mark or shape made is light-blocking.

CREATING LIGHT-BLOCKING POSITIVES

It is useful if there is a light-box to work on to ensure that the positive is opaque enough. Otherwise, regularly hold the positive up to the light, to see how opaque the marks actually are.

OPPOSITE PAGE:
Paul Clark, *Origami Bird.* This plays with optical effects of 2D and 3D.

Black paper rectangle.

Black Paper Shapes

Cut or tear black or opaque paper shapes. Your first layer may well be a black rectangle.

Opaque Drawing Materials

USING OPAQUE DRAWING/PAINTING MATERIALS ONTO A GRAINED DAFTING FILM
Paint onto the drafting film with black acrylic for full opacity. Black drawing ink, also called Indian ink, is more fluid and

responsive. Use the brush stroke wisely, each stroke will be the mark that prints. For interesting washes, dilute the drawing ink with water or methylated spirits. Experiment mixing turpentine, methylated spirit and water all together with the drawing ink to create new effects.

Draw using pen, pencil, graphite sticks, charcoal, wax crayon, oil pastel, or chinagraph pencil. See how hard you have to press to make an opaque, light-blocking mark. Try using the side of a crayon or pastel for a broad textured mark. A black lithographic crayon blocks light well and can also be smudged or even diluted with water. Use a cloth to smudge for a softer mark.

Photo-opaque marker pens are available in specialist graphic equipment shops. It is worth investing in one if you like to scribble freely as markers allow. Make marks with fingers, dip fingers onto a black ink pad. Finger paint with acrylic paint. Flick or make drag marks with an old toothbrush. Dab ink or paint with a sponge to get various textures. Try scratching back into painted areas with a scalpel, to achieve fine white lines.

If you are using a regular black marker pen, be aware that it is not as opaque as you would think but, to remedy this, it can be applied to both front and back of the positive for extra opacity.

Take rubbings of textures with wax crayon or graphite.

A black wax lithographic crayon blocks light well.

BRANDS OF GRAINED DRAWING FILM

Mark-Resist and True-Grain are the brand names of drafting film that has been grained, (that is, given a tooth), so it can hold sensitive and water-based marks resulting in marks not unlike watercolour washes. Use the rough side of the film to make your marks. If using Mark-Resist degrease with methylated spirit first.

You can make your own grained film by using wire wool and fine sandpaper onto drafting film or tracing paper.

True-Grain is expensive but, with care, it can be cleaned off and used again. Depending on what you made your marks with, clean off with water, methylated spirit or white spirit (that is, turpentine substitute).

Use a cloth to smudge for a softer mark.

Textures

TEXTURES PLACED DIRECTLY ON THE EXPOSURE BOX

Use lace, netting, string, or other low relief textures and place them directly onto the exposure box. If the texture is too thick for the exposure unit, take a photocopy of it and use that instead. Don't damage the exposure unit cover or break the screen mesh.

Indian ink is painted onto the drafting film.

Experiment mixing turpentine, methylated spirit and water to create interesting effects.

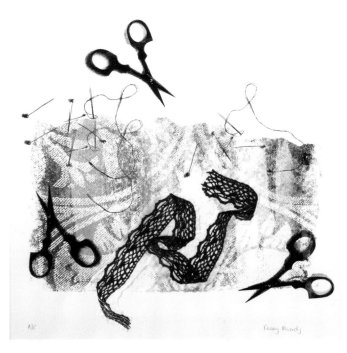

Lace makes a good stencil but take photocopies rather than use objects like the scissors and pins that might damage the exposure unit cover. Penny Mundy, *Needlework* series.

Photocopies

PHOTOCOPIES ON PAPER OR ON ACETATE

Paper photocopies work best if oiled on the reverse with ordinary vegetable oil to make them translucent. Make sure you oil right to the edge of the paper. Paper unoiled will create a positive mark on your stencil. Photocopies work better than laser copies as the carbon ink is light-blocking. Laser printing inks can be rather translucent.

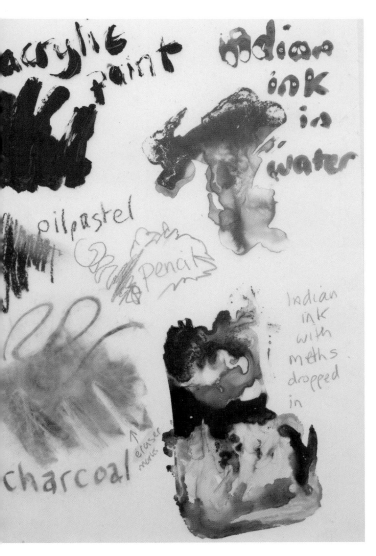

The finished print of all these marks. Notice how the charcoal has printed quite pale. Although it looks black on the drafting film, it is not that opaque.

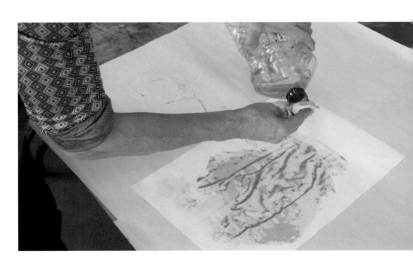

Oil the reverse of the photocopy, and make sure you go right to the edge of the paper. Paper which has not been oiled will create a positive mark on your stencil.

Photographic Positive

You can use a professionally made photographic positive. Take your work to a professional print shop to get a positive that is as opaque as possible.

Here we use vegetable oil, but any oil will do.

A FIRST APPROACH TO CREATING A PRINT

It takes a bit of mental, as well as visual, working out to understand how to separate your image into printable layers. Here is a guide to a first approach, which will also explain how to think in layers.

Using a Photocopy

Take a photocopy of an image you like. Here, a baby suit has been placed on the photocopier.

The black and white photocopy itself becomes the positive. Oil the back of it with vegetable oil, then the paper will go translucent.

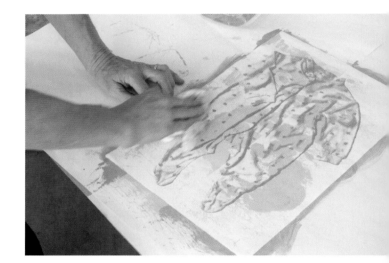

You can see the paper becoming translucent.

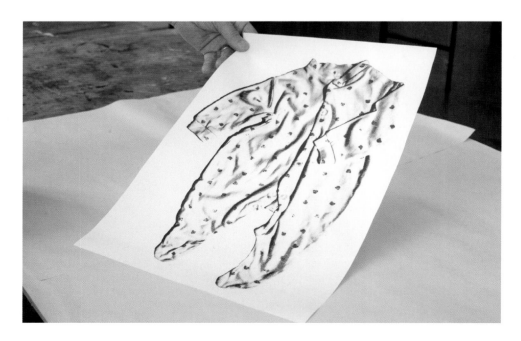

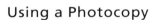

The black and white photocopy becomes the positive.

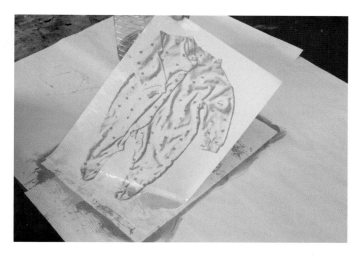

The paper is oiled right up to the edges.

You can see the paper becoming translucent.

Ensure the paper is oiled right up to the edges. This will be transferred onto the screen to be the stencil. You can print any colour you want through the stencil. Here is a print done in blue ink.

Using the same stencil, colour has been painted onto different areas of the screen to make a multicoloured image. (*See* Chapter 8 about monoprinting for fuller guidance on this method.)

Congratulations. Now you have your first print.

Babysuit **from the photocopy printed in blue ink.**

Using the same stencil, coloured inks have been dabbed across the screen where required to make a multicoloured image before squeegee-ing through.

Using a Photocopy and Cut Paper Shape

But what if you didn't want the baby suit background to be white? In fact, you wanted a blue suit with darker blue patterns. You have done all you can with the existing stencil. You have to make another positive and another stencil. It needs to be a colour field, the same shape and size as your original babysuit. To make the shaped colour field, either take another photocopy and paint it black, or cut out the photocopy shape in black paper, or use the computer program Adobe Photoshop, to make a black babysuit shape.

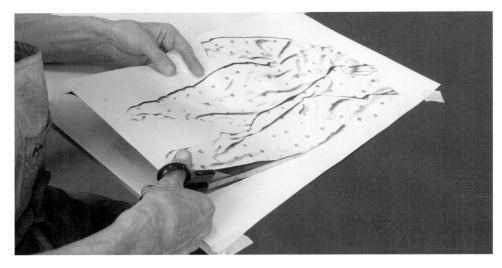

Stick the photocopy to black paper and cut around the copy.

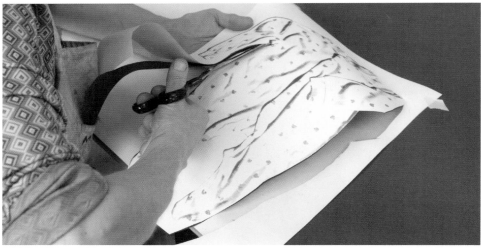

Be as careful or as sloppy as you like. A little imprecision can be visually pleasing.

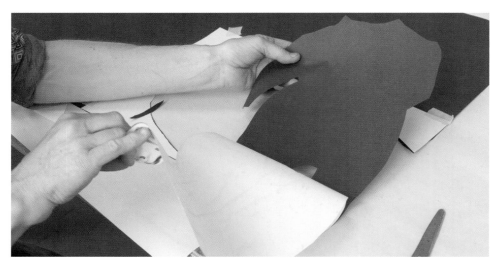

Now you have a matching stencil for your colour field.

Here, using the simplest option, the photocopy has been stuck onto a piece of black paper and simply cut around. You can be intentionally a little sloppy in the cutting out if you like. A little imprecision can be visually pleasing.

This stencil can be printed in any colour, but, if printed over the top of the last stencil, the last stencil will be obliterated.

So the colour field needs to be printed first, then the other stencil printed over that. This means you will have to start again designing the colour field as the first layer. The photocopy will become the second layer.

Now you have devised a two layer screenprint.

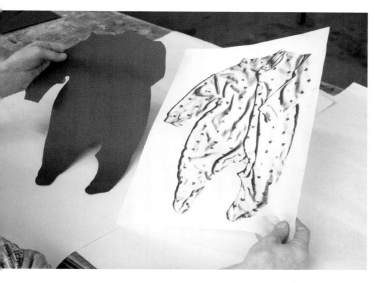

Here is your positive for stencil no.1 and for stencil no.2.

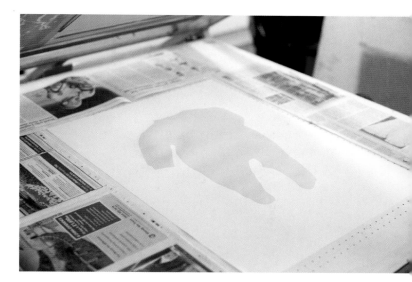

Here is your first layer.

Layer 1 and layer 2 produce the finished print.

Using Photocopies at Different Tonal Values

A photograph of a sunflower was photocopied three times, with different amounts of toner. Adjust the button on the photocopy machine for a light, a medium and a dark copy. These were oiled on the back, applied to the screen, then registered well to print precisely on top of each other in different colours or tones. A typical printmaking mental challenge is that you have to print the darkest tone positive first, as it contains the most information, but printed in the lightest colour. Then print the medium positive in the medium colour; ending with the positive from the photocopy done on the lightest setting and printed in the darkest ink.

TOP LEFT:
Light photocopy.

TOP RIGHT:
Medium photocopy.

BOTTOM LEFT:
Dark photocopy.

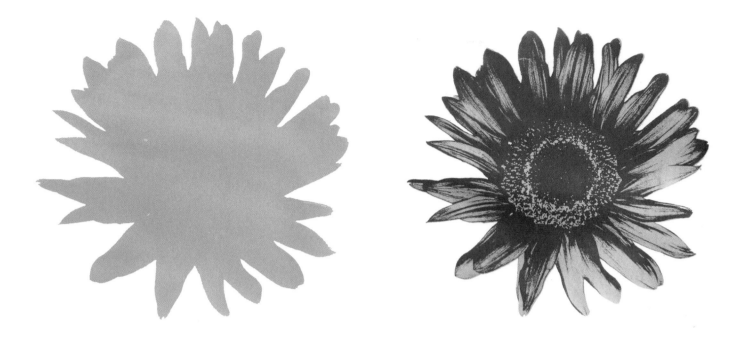

TOP LEFT:
Using the dark copy stencil,
print in pale ink.

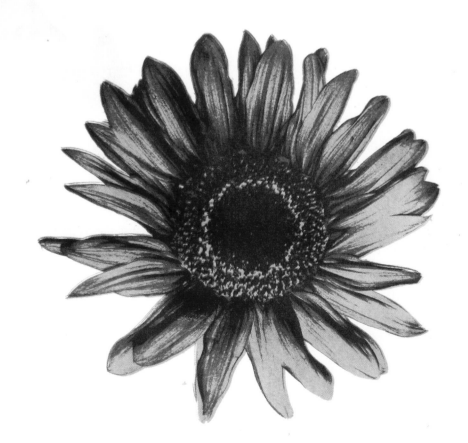

TOP RIGHT:
Using the medium copy stencil
print in medium toned ink.

BOTTOM RIGHT:
Using the light copy stencil
print in dark toned ink.

Using Multiple Photocopies and Cut Paper Shapes

In this print of bridges, printed onto brown wrapping paper, the artist's drawings have been photocopied and then oiled on the back, to be used as positives, as has the text.

The yellow coloured shapes were made from pieces of black paper cut to fit the image. They were printed afterwards in a very translucent yellow, which can be printed over the black ink without affecting it adversely. Colour fields can be printed at the end if the colour is translucent enough. A denser colour than this yellow would obliterate the first image and necessitate rethinking the layer order, printing the colour shapes first, as shown in the babysuit print.

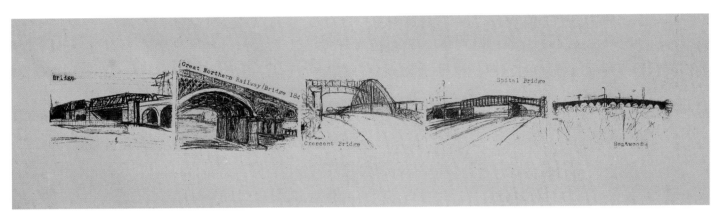

Oiled photocopies of the artist's drawings printed in black, mixed with cut paper shapes printed in translucent yellow, look effective on brown wrapping paper. By Andrew Warrington.

Three black paper shapes for the translucent yellow.

36

Using Drawn Line On Tracing Paper

A simple drawn line can become a sophisticated engaging print. In Jacques Cader's *Dynamic Lines*, the first layer positive was made from a simple black paper square. In the first image it has been printed in a single colour, orange. See, in the second image, how the use of freely applied colour (*see* Chapter 8, Monoprinting) gives a new dimension to the same image.

The second layer is made from a pen line, meticulously drawn.

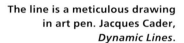

The line is a meticulous drawing in art pen. Jacques Cader, *Dynamic Lines*.

In this version the first stencil colour field has had various colours monoprinted through it.

Using Photocopied Drawings To Make A Four-Colour Print

A four-colour print has been made from four drawings. Each pencil drawing has been photocopied.

Starting with a master drawing, this has been simply sketched in four colours to correspond to the four stencils about to be created. It helps to have a light box, so the paper can be placed over the master drawing and the selection drawn for each colour.

Once four overlapping images have been drawn, the original pencil drawings can be used as positives as long as they are on very thin paper, but it is better to photocopy them so you know they are strong and dark enough to be light-blocking. Oil each copy on the back.

The yellow will be printed first, the red second, the black third. For this image the blue has been chosen to be printed last as it is intended as a modifying colour, like a lustre across the other colours.

Master drawing.

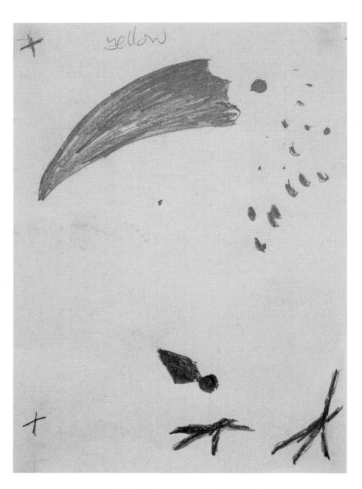

Pencil drawing for yellow stencil.

TOP LEFT:
Pencil drawing for red stencil.

TOP RIGHT:
Pencil drawing for black stencil.

BOTTOM LEFT:
Pencil drawing for blue stencil.

TOP LEFT:
Photocopy for yellow stencil.

TOP RIGHT:
Photocopy for red stencil.

BOTTOM RIGHT:
Photocopy for black stencil.

Photocopy for blue stencil. The blue will be printed last as it is intended as a modifying colour.

First colour.

Second colour.

Third colour.

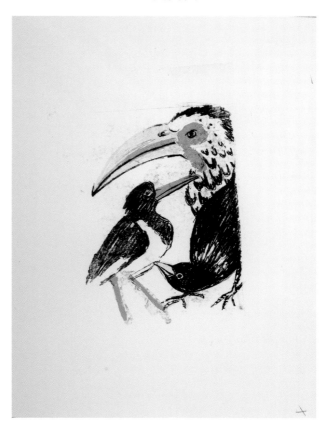

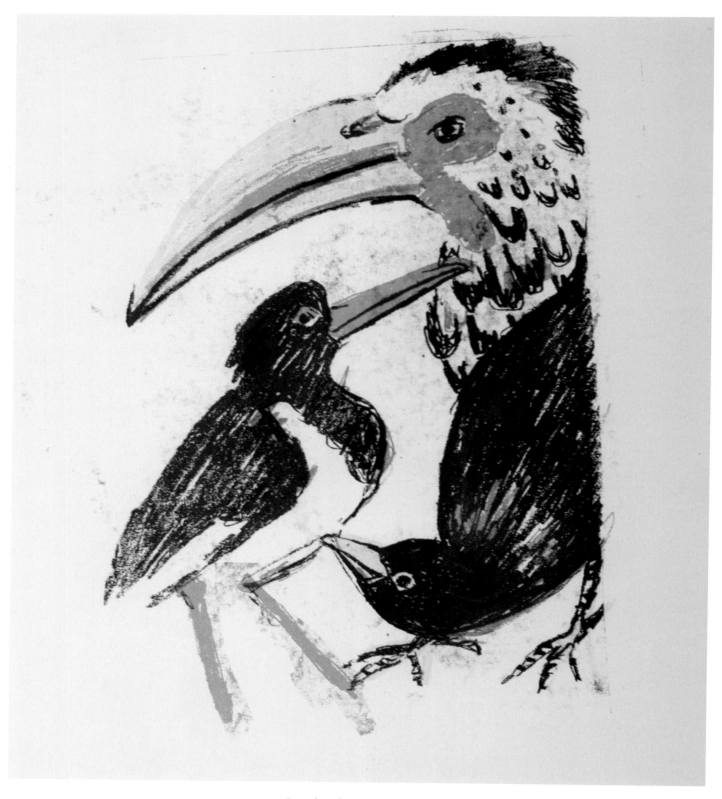

Complete four-colour print.

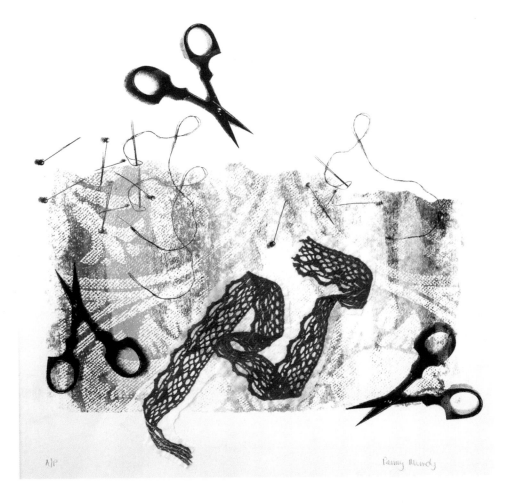

Needlework **items, printed several times in different positions. By Penny Mundy.**

Using Overprinted Photocopies

As shown in Penny Mundy's well-devised *Needlework* print, sewing items have been photocopied. There are three different layers of printing. The first layer is the fabric, which has been printed with random stripes of blues and greens. The second layer of scissors, thread and pins have been printed and over-printed in different situations. You can see both the needle and thread, and the scissors have been printed three times. The third layer of a piece of lace, printed in blue, has been printed on a piece of tissue paper and collaged onto the final print.

Using Grained Drafting Film

This beautiful image of a crow by Sophie Barr has been painted onto grained drafting film using drawing ink floated onto a

On grained drafting film, Indian ink floated into a puddle of water and allowed to settle, produced this delicate image. Sophie Barr, *Crow***.**

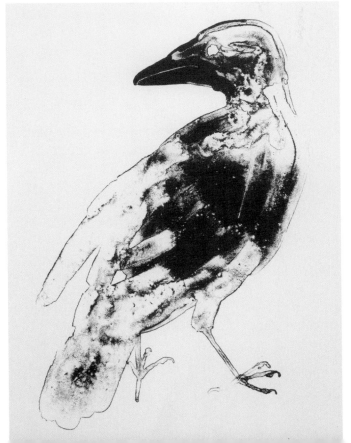

puddle of water, then left to dry for several hours. The ink separates and settles giving these delicate marks. It is a one-colour print. Had the artist wanted a background colour field, that would have to have been planned and printed first.

This use of paint on grained drafting film needs sensitivity. Use restraint when painting with the black ink or paint. Let it settle naturally and refrain from pushing it around, or all the subtlety may be lost.

In this image, a strong vigorous drawing by Andrew Warrington is balanced by use of softer washes. The artist has used a lithographic crayon to draw. Drawing ink was floated on water for textured tones. In places this drawn line dissolves, softens and blends with the water washes.

Here is the image again, printed on brown wrapping paper. As you can see, the marks you can get on the grained drafting film can be very free and delicate, close to the qualities of a watercolour. This delicacy can be combined with the strong colour that screenprinting allows, to exquisite effect.

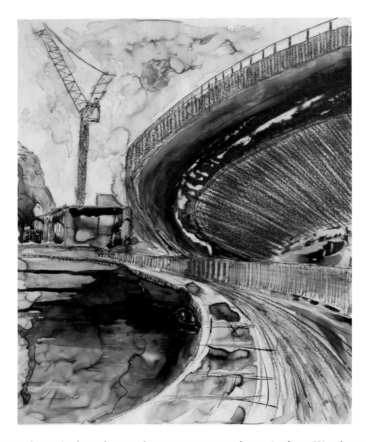

Floating Indian ink on water, the artist has also used a wax crayon to draw. Andrew Warrington, *Under The Motorway*.

Using Grained Drafting Film with Cut Paper Shapes

The complex and delicate drawing on grained drafting film is contrasted with the strong simple colour fields made from paper shapes in another version of Marie Coccolatus' *Amphora* print.

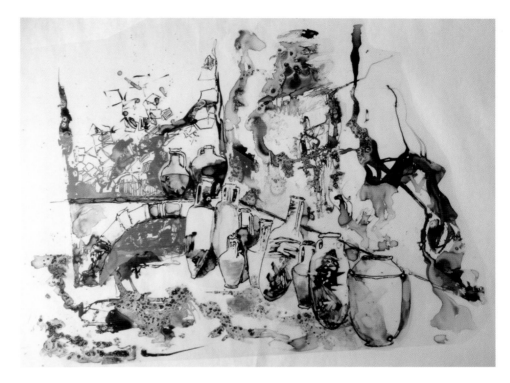

A sheet of grained drafting film with a drawing done in Indian ink. By Marie Coccolatus.

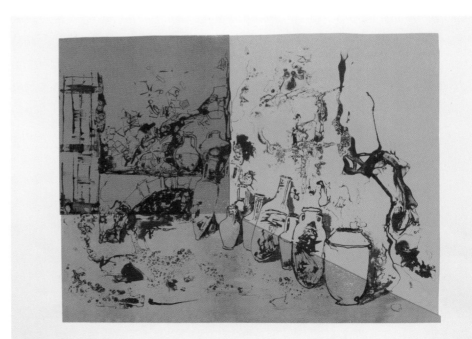

The drawing printed over three separate colour fields. By Marie Coccolatus.

Building up varied multi-layers. Esther Sunyer Parellada, *Desperate Gardens 1*.

Building up Varied Multi-Layers

As shown above in the *Needlework* print, one of the delights of screenprinting is that you can find images that interest you, apply them to the screen, then print them anywhere you fancy on the paper, creating and changing your composition as you print. Expose as many images onto your screen as will comfortably fit. Choose one, and cover the others up with brown plastic parcel tape and shiny paper. Using a small squeegee, select and

print one item at a time. This gives endless possibilities. You can see the same elements used in different colours and different placings in these exciting prints. Some of the stencils have been printed on different papers and collaged back onto the finished print.

Esther Sunyer Parellada uses her drawings and photographic images. They are photocopied, collated and printed in different colours, creating different inventive compositions each time and building richly varying narratives.

Using a Painted Image With Colour Fields and Blends

The actual make up of this design by Paul Clark is fairly simple, but it looks highly complex and engaging. This is something screenprinting does very well, using strong colours and intriguing layers. The background was a large rectangle divided into two, masking off one area at a time. The lime yellow was a straightforward print. The other section was pulled using a 'blend' or 'rainbow pull' (*see* Chapter 8) in grey and transparent white. The positives for the pink shapes were drawn in black ink on tracing paper then printed on top. If you look carefully, you

To keep colours strong and bright, you may have to print white through the stencil first, then re-register to print the desired colour on top. If you look carefully, you can see the shapes were printed twice, first in white and then in pink. By Paul Clark.

The artist's drawings are mixed with photocopies, collated and printed in different colours. Esther Sunyer Parellada, *Desperate Gardens 2*.

can see they were printed twice, first in white and then in pink. This is to ensure coverage over the strong colours below. A tiny bit of mis-registration enhances the impact of the image. The resulting image is an impressive balance of shape and colour with suggested visual perspective.

Using Photographic Positives Composed on the Computer

Photographic images can be manipulated in Adobe Photoshop or other computer programmes. Though, remember, each positive must be printed out in black to ensure it is light-blocking.

These images by Lynne Blackburn begin as digital photos taken with a low quality camera phone. They are then taken through a lengthy process of digital deconstruction and reassembly, and printed as multi-layered screenprints. In *Neither Hopeless Nor Helpless* the artist breaks down the digital image into layers of pixelated colours; these layers are then rotated, distorted, repeated and re-arranged into beautiful 'mandalas'. These are then hand screenprinted in very small editions.

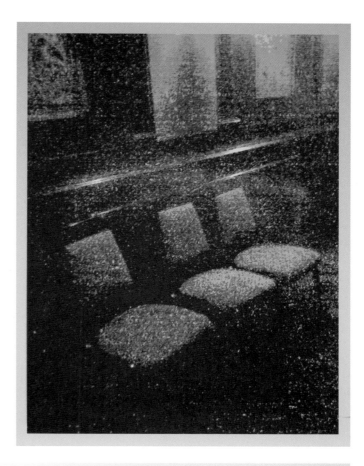

A seven-colour (i.e. seven stencil) print on textured paper made from digital photographic images manipulated and deconstructed on the computer. Lynne Blackburn, *Three*.

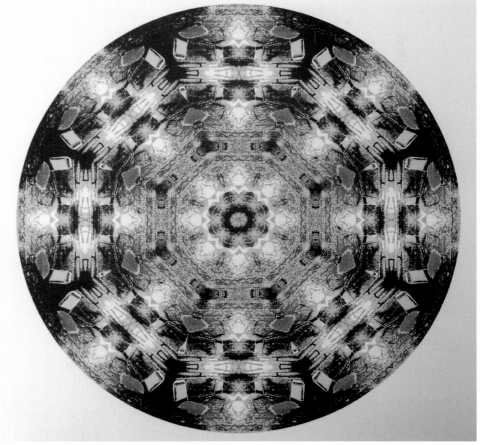

A similar seven-colour digital image of chairs is manipulated into a mandala design. Lynne Blackburn, *Neither Hopeless Nor Helpless*.

Yo callo
Tú callas
El calla
Nosotros callamos
Vosotros calláis
Ellos callan.

'Despierta Gordano 4'

¹/₁ E. Sarriger 99

SCREEN PREPARATION

Let's hope that your screen is entirely clean and ready to use. Hold it up to the light to see if there are any specks blocking the mesh. If it's clean you can coat the screen. If not, read on through this paragraph to see how to clean it.

REMOVING OLD SPECKS THAT ARE BLOCKING THE MESH

The most efficient way to totally clean a screen of old marks is to use highly caustic Alkaline Cleaning Paste. Wear protective gloves, apron, goggles, mask or respirator. Brush paste over the screen and leave it on for at least forty-five minutes. Wash off, first with gentle pressure, to get rid of the paste, then with the power blaster.

However, you can often blast the problems away without the use of heavy duty cleaners by just using the power blaster. Usually it is necessary to soften the offending specks first. If they are composed of old ink, place the screen on a table with newspaper below. Squirt a drop of heavy duty bathroom cleaner on the spot and rub hard with force; you usually need a blunt object, for example, the rounded handle of a plastic palette knife. Sometimes methylated spirits will do the trick too. If the spots are composed of old stencil emulsion, then a drop of stencil remover left on for three minutes will do the trick. (Don't let the stencil remover dry on the screen.)

COATING THE SCREEN

Degreasing

Degrease in the sink or wash out trough. Wearing gloves, apply degreasing solution to a cloth or designated brush and wipe it over the whole mesh area on both sides. Rinse with cold water. Either leave the screen to dry or blot it dry with clean newsprint. The screen must be completely dry before coating.

Coating with Photographic Emulsion

Coating is done on the flat back of the screen, not the printing/squeegee side.

Take care of the coating trough. The edge that touches the screen must be clean and dent-free. This one is protected when not in use. You may have to attach the sides to the trough; just line them up and push them on.

In the dark room, (or in a dark corner), fill the coating trough evenly across its length, about one-third full of emulsion.

Close the lid of the emulsion pot. Lean the screen against a wall at a steep angle with the flat side facing you. Place the trough so it is touching the mesh at the bottom of the screen, making sure not to be touching the sides of the frame.

Tip the trough, and wait until all the emulsion is touching the screen from one end to the other. With a small amount of pressure, glide the trough up the surface of the screen until a few centimetres from the top edge.

Tip the trough back to a flatter angle and glide up the last centimetre or two.

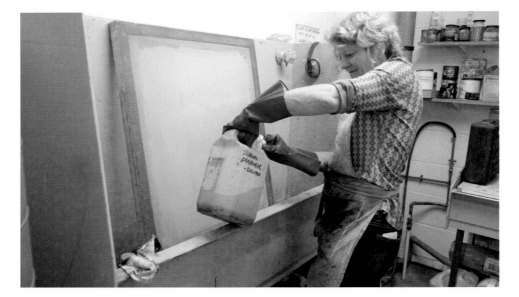

Wearing gloves, put some degreaser on a cloth.

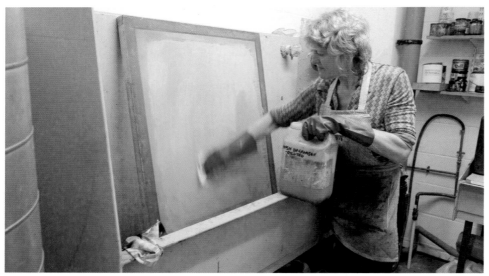

Wipe the degreaser across the whole surface of the screen.

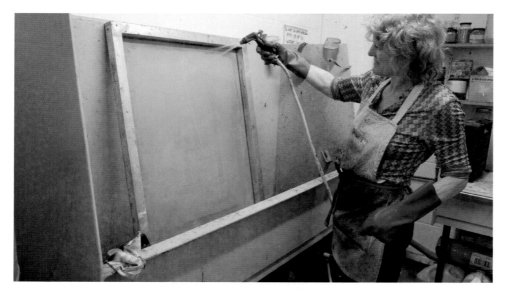

Degrease the other side too, and wash off with water.

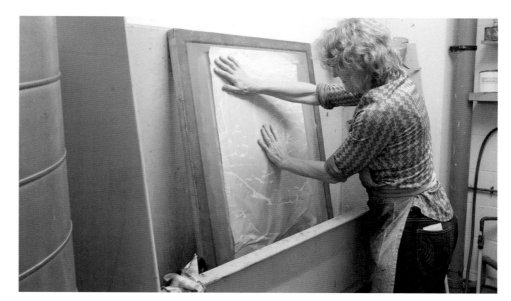

Blot with clean newsprint, or just dry the screen in front of a fan.

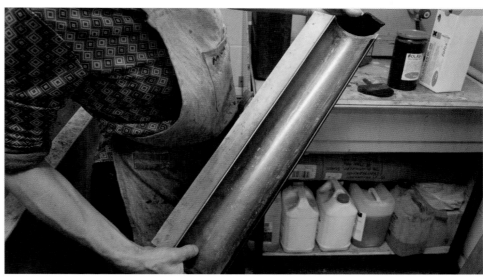

Take care of your coating trough. The edge that touches the screen must be clean and dent-free. You may have to attach sides to your trough.

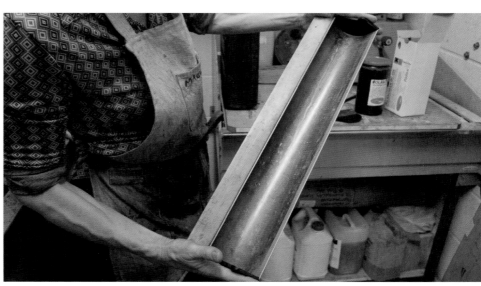

Line the sides up and push them onto the trough.

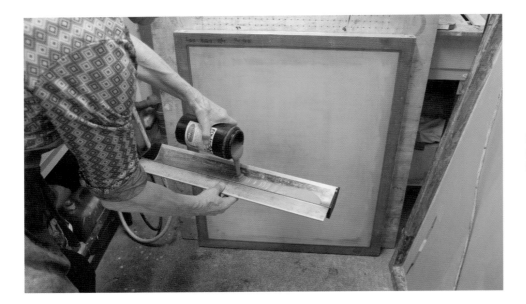

In the dark room, or a dim corner, pour photographic emulsion into the full length of the trough.

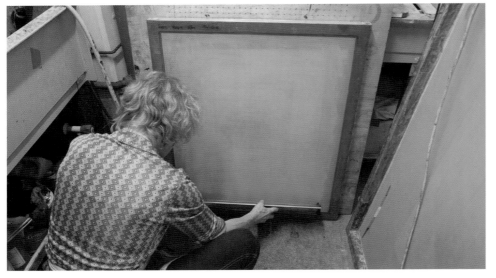

Position the trough at the bottom of the screen. Make sure you're not touching the frame. Tip the trough and wait until all the emulsion is touching the mesh before you start.

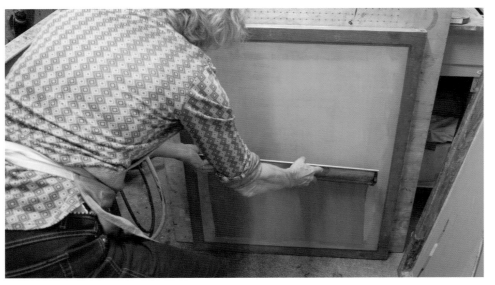

With a little pressure, slide the trough up the mesh.

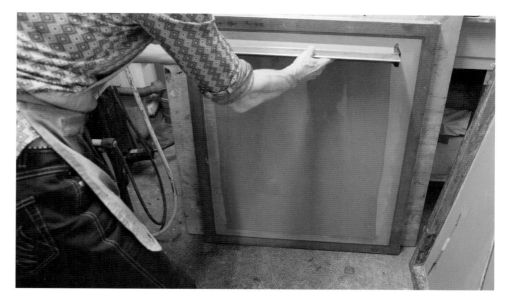

Tip the trough back just before you reach the top to prevent dripping.

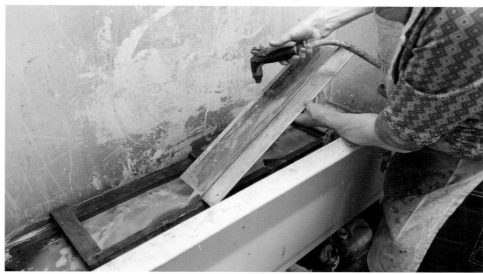

Clean the trough straight away with water, ensuring the edge is completely clean.

Place the screen to dry in a dark area. A blow drier will speed up the drying. Remember the screen is now light-sensitive. Replace unused emulsion back in the pot. Clean the trough thoroughly with water, taking care of that precious edge!

If it didn't work? Perhaps the pressure was uneven – make sure not to touch the frame. Perhaps you ran out of emulsion – always put out more emulsion than you need. Perhaps you touched the wet surface when moving it to the drier – then wash it all off with water, dry and start again.

The dry screen can be stored in a dark place for a while. If it can be kept completely dark, it will store for several days.

EXPOSURE AND WASHING OUT

Your light box will probably have the exposure times already worked out. If not, you will have to do some test exposures. *WARNING! The light can damage your eyes. DO NOT look directly at the light at any time.*

Make sure the glass top of the unit is clean. Any specks will come out as a mark in the stencil. Position your positives the right way up, for example, as if it were text, so that you can read it. (It may be easier if they are all in the same orientation, but not entirely necessary. Later, you can turn either the screen or the paper around, to print images in any direction.)

Place the screen flat side down over your positive, making sure your positive is at least 5cm away from the edges of the screen.

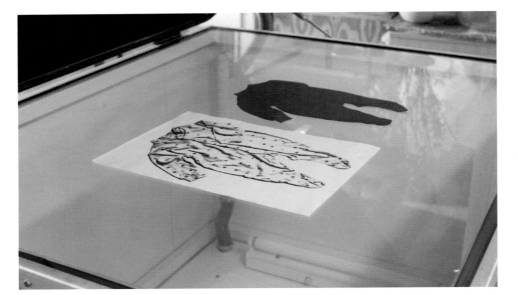

Position your positives the right way up.

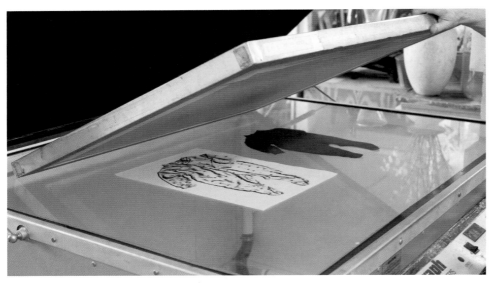

Place the screen flat side down over your positive.

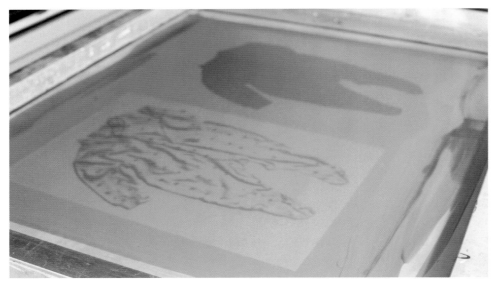

Make sure your positive is at least 5cm away from the edges of the screen.

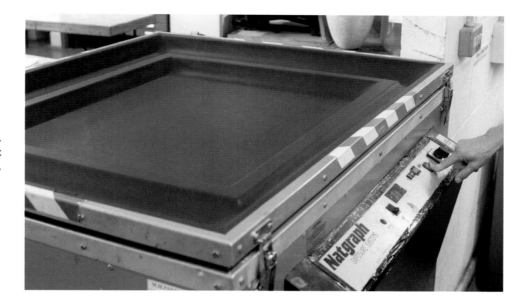

Close the lid. Turn on the vacuum. You can see it sucking down tight over your screen.

EXPOSURE WITHOUT A VACUUM

If there is no vacuum, you will need a thick sheet of MDF cut to fit snugly inside your screen. First place some layers of newsprint or a soft thin blanket on the back of the screen, then place the MDF. Press firmly down on it to ensure a good contact while it is being exposed. *Remember to protect your eyes.*

Close the lid. Turn on the vacuum. You can see it sucking down tight over your screen.

If the exposure unit is fully automatic, switch on and wait for it to do its business. (Some units need to warm up the light bulb for ten to fifteen minutes before exposure.) When it has

finished the exposure, turn off the vacuum, slowly ease up and lift the lid.

Remove the screen, and quickly take it to the wash-out room (remember it is still sensitive to light) and straight away wash with a cold water spray. Wash both sides with cold water.

Check that the image is fully clear by holding the screen up to the light.

Dry either by blotting with clean newsprint, (do not rub, the emulsion is still a bit soft) or leave to dry. A blow drier will speed things up.

If there are pinprick holes in the stencil, they can be filled with a tiny amount of emulsion scraped on thinly with a piece of card or plastic. Then re-expose to harden it, or leave in bright sunlight. Alternatively, use a tiny scrape of hand-paint ('Speedball') screen filler. But, don't get too worried, often these holes close up and are undetectable when printing.

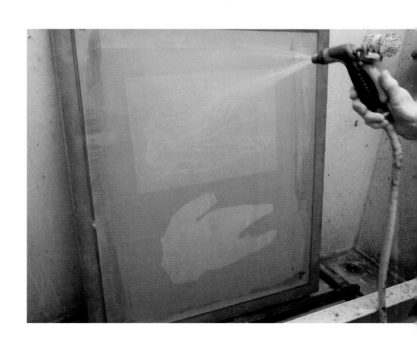

Quickly take the screen to the wash-out room (remember it is still sensitive to light). Spray the back and front of screen across the whole surface.

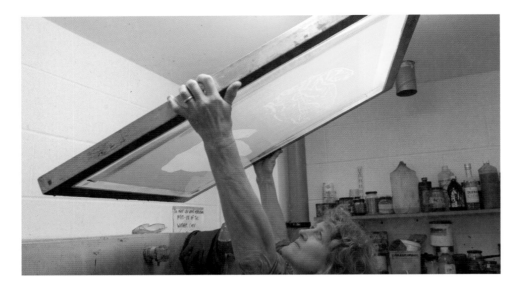

Check that the image is fully clear by holding the screen up to the light.

SETTING UP THE SCREEN READY TO PRINT

Tape the edges of the screen with parcel tape.

Cover any open areas of mesh and also cover over the join between the mesh and the frame.

Clamp the screen onto the bed.

Tighten the clamps so the screen doesn't move when printing. Check for 'snap': the screen mesh should never be touching the paper on the bed, but have a gap of about 4 or 5mm (this is the snap). Then, as the squeegee passes over, the screen 'snaps' back away from the paper surface. With too little snap, you can get the paper sticking to the mesh. With too much snap, you will have difficulty printing and may get thick deposits of ink around the edges of the image.

Cover any areas of the screen you don't want to print, preferably with shiny paper so the squeegee glides across it. Cover any vacuum holes around your printing area with newspaper secured with masking tape, to get efficient suction.

Cover over the join between the mesh and the frame.

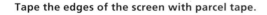
Tape the edges of the screen with parcel tape.

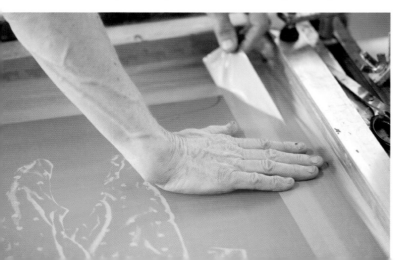

Tighten the clamps so the screen doesn't move when printing.

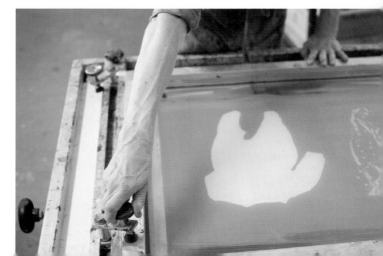

Cover any areas of the screen you don't want to print.

Cover any vacuum holes around the printing area with newspaper.

PRINTING WITHOUT A VACUUM

If you have no vacuum, you will have to remember to lift the screen and peel the print away from the mesh before you flood back.

If you are printing large areas, stick the paper to the bed at the corners with masking tape. Not only does this ensure that you get no 'peel off' marks, but, should you want to intensify the colour by printing twice, the print will still be in register.

Stick the paper to bed with masking tape.

HAVING EVERYTHING TO HAND

Set up all you need before you start, so you know where everything is. Once you start printing, you don't want to have to hesitate or delay. Remember, the ink may dry in the mesh if left too long.

You will need a bucket of water, a sponge, a dry cloth (this is invaluable – keep it clean and dry throughout), a stack of newsprint, a stack of newspapers, masking tape, pencil, registration acetate, squeegee, jars of ink, plastic palette knives, pieces of card or old credit cards and prepared printing paper. It could be handy to have a water spray/atomizer.

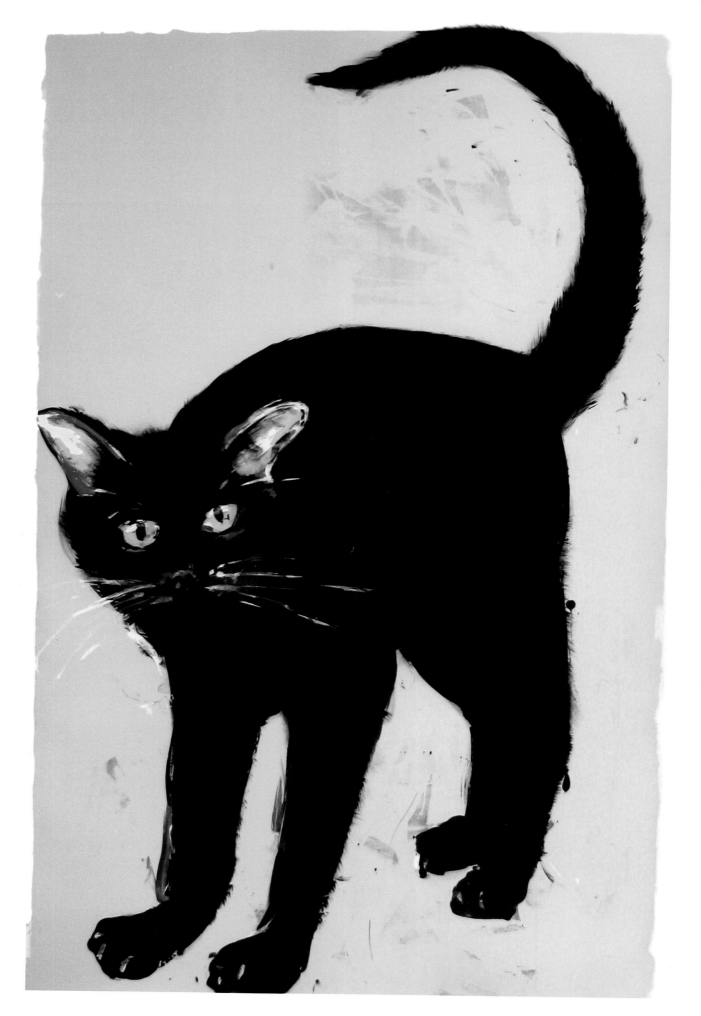

MIXING COLOURS

ABOUT COLOUR

Colours are described with the terms 'hue' and 'tint' or 'shade'. Hue is the actual colour. Tint is that colour or hue with white added. Shade is that colour or hue with black added.

Theoretically we work with three colours called 'primaries', that is red, blue and yellow. These three, when mixed, should give us any colour or hue required. The addition of black or white will give the shades and tints.

In the case of screenprinting, it is often better to create a paler colour, or tint by using the clear screenprinting medium, rather than adding white pigment (*see* the section below on 'white'). The 'Colour Wheel' describes the basic primary and secondary colours.

There are three primary colours in the middle: red, yellow and blue. The 'secondary' colours are a mixture of two primaries. Red and yellow create orange. Yellow and blue create green. Red and blue create violet (or purple). The colour opposite in the wheel to the primary is called a 'complementary' colour, or 'opposite' colour.

If you mix a primary with its complementary colour it will create a murkier, more organic-looking hue, eventually becoming a dull grey. If you print two complementary colours side by side the eye will usually be boggled with the intensity.

Again, in printing, if you want to lighten the hue, remember it is usually preferable to mix it with screenprinting medium rather than white paint. White can give a different effect from the transparent medium. White with red instantly becomes

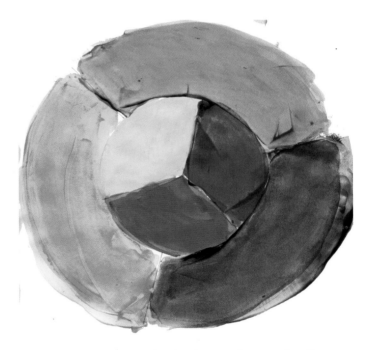

A traditional colour wheel. Primary colours: red, yellow, blue. Secondary colours: orange, green, violet (or purple). Opposite or complementary colours when mixed create grey.

pink, but, using the medium to dilute it, it seems to retain more of its 'redness'. Try it out.

OPPOSITE PAGE:
Maggie Jennings, *Black Cat*. A large vivid monoprint size 130cm x 92cm.

Trichromatic range, also called process colours. Cyan, Magenta. Yellow, Black.

USING THE TRICHROMATIC RANGE – CMYK

Commercial screenprinting uses a set of coloured inks that have been carefully formulated and balanced so that, when mixed together in the correct proportions, they should represent the whole colour spectrum. This is called CMYK, which stands for cyan, magenta, yellow and black.

The printing inks for this range are often called 'Process', for example Process Blue, Process Magenta, Process Yellow, Process Black. If you see acrylic paints with this title (as in the System 3 range) then use them as your basic set of colours.

You may see the code name CMYK on computer printers. If you look at a newspaper photograph through a magnifying lens you will see thousands of miniscule dots of colour. These are the result of a four-colour separation, separating the image into cyan, magenta, yellow and black.

Separating an image for trichromatic printing is quite technical. Once done with colour filters in the darkroom, it is now accomplished in computer software. If you are adept at Adobe Photoshop you can produce your own separations fairly easily. It involves separating the image into four colours (cyan, magenta, yellow and black), then creating 'half-tone screens' of each separation. A half-tone screen is made up of thousands of microscopic dots. The resulting four separations must be printed out in black on acetate to be used as a positive.

Care has to be taken not to get a moire effect on the screen. This is when the dots that make up the image collide visually with the regular grid of the mesh and give an optical whirling. Moire dots per inch must not coincide with mesh openings per inch. A good guide is that the mesh size is much finer than the moire dot size.

TRICHROMATIC INKS WITHOUT THE COMPLICATIONS

You can still use the Trichromatic range without having to go to all the trouble of creating half tones and separations. Plan your layers to overprint, so creating your own colour mixes. You can learn a lot about colour mixing from this method. Experiment by figuring out just how much magenta it takes to change a straight cyan into an Ultramarine blue. How much yellow must be added to magenta to create a red?

The colours in the Trichromatic range sometimes feel glaring and harsh. Although they, theoretically, make all colours, many artists have a personal and intuitive response to colours and like to choose a colour they are happy with to start with. Mixing Trichromatic inks takes almost mechanical precision to work out just the right amount of each colour. Most artists work with more colours that the three in the Trichromatic range.

Trying to mix the colour in your mind's eye can be frustrating. The colours your eye perceives are formed of light. The colours you buy as the pigments and dyes used in inks don't work in the same way. Traditional pigments come from various sources in nature. Ground earths, minerals and plants gave early artists their palette. They don't necessarily mix well to form the colour you had in mind. Today, when choosing colour in the art store, there are a bewildering array of colours to choose.

BASIC COLOUR STOCK

To create a basic colour palette it is best to stock up with a minimum of seven basic colours. Cheap ranges of colour acrylics may be bulked up with binders. Go for the best you can afford. Depending on the source of the colour the price will vary dramatically. Pure Cerulean blue will cost a great deal more than an earth colour like Terracotta.

A good basic colour store would consist of:

- Two blues – a green-shade blue such as Cyan, and a violet-shade blue such as Ultramarine.
- Two reds – a yellow-shade red such as Vermilion and a violet-shade red such as Crimson.
- One yellow will usually suffice, a mid-tone or Cadmium yellow
- One black

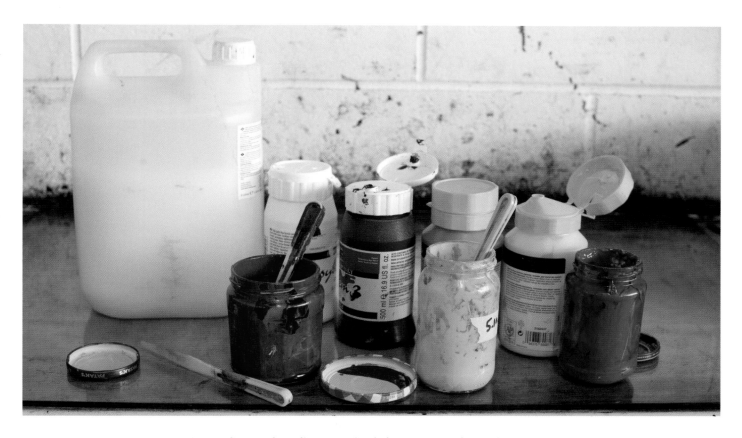

Printing medium and acrylic paint mixed about 50:50 make up the printing ink.

- One white
- All hues, tints and shades should be able to be mixed from these colours.

Although brown can be mixed fairly easily from the three primaries, it is nice to have a ready-made one. A Terracotta for red shades and a Vandyke brown are good. Magenta is also a good addition to the range. If you want a pure clear turquoise or violet, it may be better to buy one as well.

Colours may be described as 'cool' or 'warm'. This can be quite a personal perception with some disagreement. Blues and violets are described as 'cool', but a red-shaded violet may appear quite hot to some viewers. Strong yellows and reds are 'warm', but a pale lemon yellow may feel quite cool.

Experiment with mixing colours. As an exercise, try mixing your colours to get a violet or purple. Theoretically one uses blue and red. Use a violet shade red, for example Alizarin Crimson, mixed with a red-shade blue, for example, Ultramarine. That should be a passable violet or purple. Now see what happens when you mix a yellow-shade red, for example, Vermilion, with a cyan-type blue. You will get a very different colour. You can achieve many variations of 'purple'.

One of the hardest colours to achieve is an organic green, the sort we see in grass and trees. Try mixing the basic blue and yellow, then add tiny quantities of the complementary colour to green, which is red. Spend time achieving the colour you want.

PAINTS CAN BE POISONOUS

BEWARE
- Some paints are made from fairly poisonous matter. Heavy metals, such as cadmium may be used for reds and yellows; cobalt for blue; arsenic for green.
- Make sure you don't ingest any paints or inks.
- Don't bring food or drink into the print room. Wash your hands before touching foodstuffs.
- Don't dip your paint brush in your coffee mug.

MIXING THE COLOUR TO MAKE PRINTING INK

Water-based screen printing inks are made up of a printing medium (also called printing base) and acrylic paint.

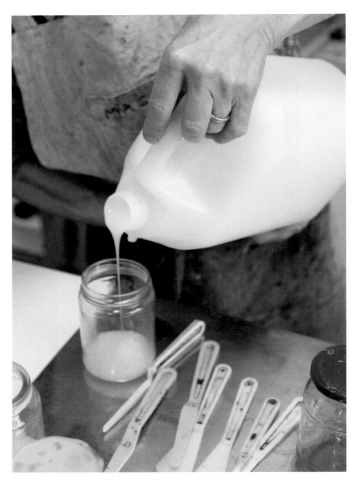

Put some printing medium into a jar.

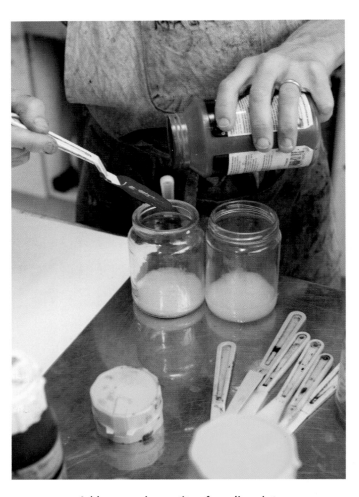

Add an equal quantity of acrylic paint.

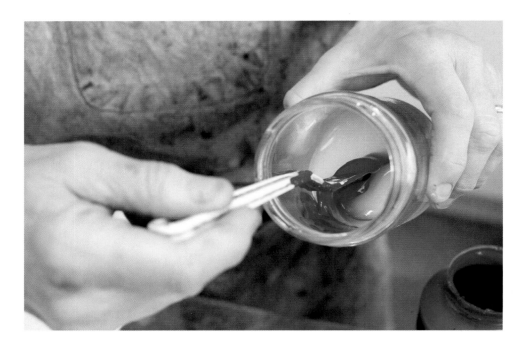

Mix well, it takes quite a bit of mixing.

The same colour mixed with more medium to make a more transparent colour.

You can use any make of acrylic paint – it all works. The better quality of paint you have, the better the colour quality. Some pigments are more expensive, but it's really worth getting the finest colour possible. After all, we are focusing on colour here.

Put some printing medium into a jar. Now add an equal quantity of acrylic paint and *mix well.*

It takes quite a bit of mixing!

Now you have transformed your paint into a printing ink.

Beware, if you mix your acrylic colour before adding it to the medium, acrylic paint dries very fast and can even start drying as you mix; starting with the medium prevents this. One annoying peril of acrylic paints is that they dry on the sides of the jar. Try to avoid dried bits of ink, they will make flecks on your image or block your screen. Wipe away crusty edges with a damp rag.

If, when you print, you get marbling, with swirls of different strengths of pigment, you haven't mixed your ink well enough.

Please make sure you never ever use unmixed acrylic paint straight on the screen, it will quickly dry in the mesh and be almost impossible to remove. Colours can be made more transparent by adding more printing medium.

If you want a colour to be as opaque as possible you can use the ratio of about 60 per cent acrylic to 40 per cent medium, but do be very careful not to let it dry in the screen. Keep an atomizer filled with water at hand. Or use Retarder.

Balance your colours tonally. The colours are bright and strong when printed on white paper, don't have them all at the same hue or tonal value, darken or lighten some. It's often a mistake to mix all your colours to the same intensity. Try making different transparencies of the same hue. Make some

of them dull and heavy to create balance. Include dark, light, dull, bright.

Try scraping a thin swatch of ink onto some white paper to get an idea of how it will print.

Remember, the screen only lets through a very thin layer of colour, so make sure you have made your coloured ink strong enough. As a simple remedy for a weak colour, you can print the same colour twice straight away while the paper is still in register and this will make it twice as strong,

It is hard to tell just how your colours will print until you actually print them. They don't work in the same way as when you paint. It is also hard to judge how colours will work together until printed: so try out several different colours with each stencil. Be bold. Be a bit wild. Try a colour you hadn't even thought of – a colour that surprises you. Don't be literal. Sky doesn't have to be blue. Grass doesn't have to be green. Often the most unlikely colours work.

OTHER PAINTS TO MAKE SCREENPRINTING INKS

Other water-based colours can be used to make screen-printing inks, but watercolour usually gives too weak a colour; gouache has too much binder in it; drawing ink colours are notoriously fugitive and may lose their colour over the years; concentrated screen tinters are excellent but might involve too much financial outlay to start with.

These two jars look the same colour, but one has more base.

Retarder

A retarder is available for screenprinting inks. This is especially helpful if you are printing somewhere hot and dry. Also, if a very dense colour (especially black) is required, then the ink can be made of more acrylic than base, with a spoonful of retarder added into the mix.

White

Usually the paper gives you your white. To achieve lighter colours, use more medium. However, if you want actual white, or pale colours mixed with white be aware that it is quite opaque. Use it with care. It can stand out in a strange way and affect the visual perspective of your image. Use it creatively like a veil. Mix it with extra medium to half obscure and give ghostly effects.

To see a good use of semi-translucent white ink, *see* Chapter 8.

Keeping the Inks

Mixed colours will keep many months if kept sealed in an air-tight jar. Put a tiny layer of water on top to prevent the ink from drying out.

Mix different hues and tones.

Scape a thin layer onto white paper to test colour.

9/20 "You don't know Jack!" Maunders 2013

PRINTING

After all the work you have done to create your image, you are now ready to set up and actually print. Printing can feel a bit panicky at first, as everything has to be done swiftly to prevent the ink from drying in the screen. That is why it is essential to have everything you need at hand before you start. But first you must prepare the paper.

PAPER

Paper is an integral part of your print. Printmakers usually have a passion for their papers, developing relationships with their favourites. It is worth investing in good quality, acid free paper for longevity. It's a shame to do all that work and then put it on any tatty old scrap. Good quality art paper should be acid free; ask the paper supplier. The acid in cheap paper causes it to discolour and become brittle with age. The best papers are made from cotton rag rather than wood pulp. Thin paper is not good for printing many layers of ink, it may cockle. You really want a heavyweight paper: 240 or 300gm is best. You can get away with lighter paper if you're only printing one or two layers. Choose a paper with a smooth surface; the ink will not print evenly on textured papers. Cartridge will do perfectly, for example 'Heritage 300gm' - you can even tear sheets from your sketch pads. For something more luscious; a soft, heavy, lightly-sized printmaking paper like Somerset Satin 300gm is a delight. This has a deckle edge rather than a sharp cut edge. A deckle is the irregular edge that is formed when a sheet of paper is made in a mould; the deckle being the frame that holds the paper slurry. Deckle edges are beautiful, though they need more care when registering.

Paper is 'sized' with a type of glue. The more size, the harder and glossier the paper will be. Papers with less size are softer, the ink will sit into the paper rather than on it.

White paper will give the most brilliance, but softer, off-whites, for example 'Book-White', 'Natural', 'Parchment' or 'Cream' may be more sympathetic. If using coloured papers, remember that inks are translucent and are affected by the base colour. Try soft buffs and grey, (Arches or Somerset). 'Ingres' papers have many subtle and speckled shades, though they are really designed for pastel and are rather thin.

Japanese tissue can be lovely, but take care when it gets wet, it can easily disintegrate. It's fun to print on brown wrapping paper, old magazines and newspapers. Black paper gives another way to work.

PRINTING ON FABRIC

These inks aren't designed for fabrics, and won't wash well, so don't plan to print clothing; but that doesn't stop you trying out printing on various fabrics for their visual effect. Fabric printing equipment differs from what we are using, in that the screens have a coarse mesh and use a rounded squeegee to deposit a thicker layer of ink to soak into the cloth. The medium is composed differently (see Chapter 9 on Home Kits including textile printing ink).

Choose smooth texture cloth, as only the top surface of a heavy weave will get printed. Stretch the fabric over a piece of card and secure it with masking tape. You may have to pull several layers of ink to get a good print.

OPPOSITE PAGE:
Paul Munden, *You Don't Know Jack.*

Make sure you have a good border around the image. Don't be mean, let the image breathe, give it the space it deserves. Apart from the aesthetics, if the border is too small then you may have trouble with the print sticking to the screen after pulling. I would suggest an absolute minimum of 20mm. Always allow a bit more space below the image, as this is where you will be writing your signature, title and edition number.

It is helpful if all your paper is the same size. If you have different sizes of paper you will need different registration marks for each size.

SQUEEGEE TECHNIQUE

Correct squeegee technique is essential to printing the work. Expect to practise 'pulling' the print a few times on newsprint to get the angle correct, before starting on good paper. The correct angle is essential for a good print. This includes the correct angle on flooding back as well.

Look after the squeegee. The blade should be sharply squared off with no nicks and no waviness along the length.

It is the sharp corner of the blade that does the printing, so the angle that it is held it at is vital: about 45 degrees is best.

The angle must be the same across the whole pull. It is tempting to change it as you near the end. *DON'T*, or you may get bleeding and too thick ink at the edges.

Hold the squeegee symmetrically, just in from the edges. The pressure must be even. Think about your left and your right hand. Are they working equally? Now try it on some newsprint.

Get into the habit of placing the inky squeegee down in the same place each time you finish pulling your print, to limit the surrounding mess; usually on the side of the screen, up against the back lip so it doesn't slip and slide when the screen is lifted.

The blade should be at a sharp 45 degrees angle.

Make sure there are no nicks in the blade.

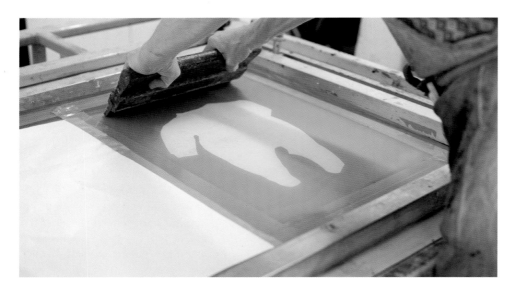

Always be aware of your squeegee angle and keep your pressure even across the blade.

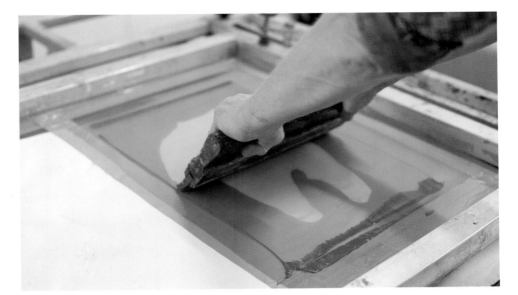

Keep the correct angle all the way.

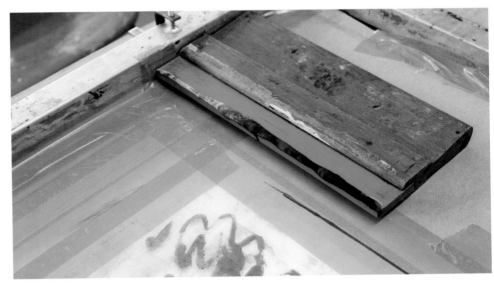

Get into the habit of placing your inky squeegee down in the same place each time you finish pulling your print; up against the back lip is best so it doesn't slip when you lift the screen.

REGISTRATION

You will need a sheet of acetate larger than your printing paper, and registration marks, either made of masking tape, or small pieces of card with double-sided tape.

Place the master drawing on a sheet of the printing paper where you want to see it printed (remember to give it the space it needs); it helps to lightly tack it down with a tiny bit of masking tape. Securely attach a sheet of acetate (with masking tape, by one edge) to the bed so you can fold it back like the page of a book.

Print the stencil onto the acetate. Slide the master drawing under the acetate and manoeuvre it to line up perfectly with the printed image. This usually takes a bit of fiddling, lifting and lowering the screen, checking from above and adjusting below, to get it right. Use this method for each successive stencil. Here the second stencil is being registered to the first stencil.

Place two registration marks at the bottom left-hand corner and one along the bottom edge. This is the 'corner and bar' method. Don't be tempted to register two corners, that can lead to mis-registration.

If you are also using a different sized paper, put one in place now and place more registration marks for it.

If the first stencil is a rectangle, as is quite often the case, you don't have to print the whole rectangle. You could save ink and cleaning time by just printing the two side edges. Get into the habit of leaving the acetate in position, folded back. It can be very handy for checking dodgy registering, especially in later layers.

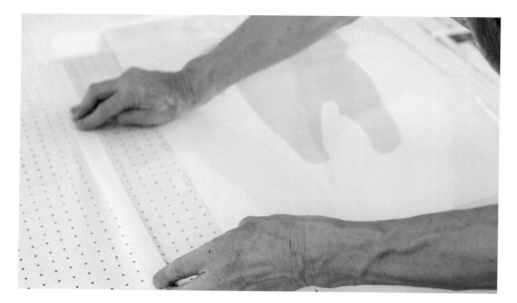

Securely attach to the bed a sheet of acetate, using masking tape along one edge.

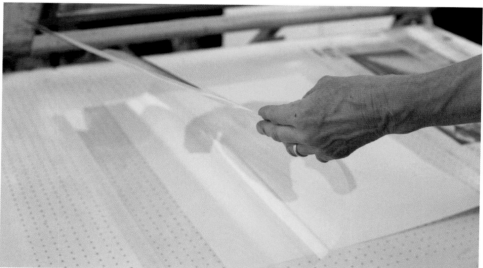

Peel the acetate back like the page of a book.

Print the stencil onto the acetate. Here the second stencil is being registered to the first.

Slide the print under the acetate.

Spend some time lining up the images.

Place two registration marks at the bottom left hand corner and one along the bottom edge. Here pieces of card stuck with double-sided tape are used.

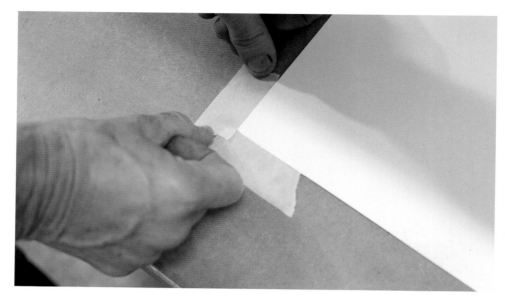

Masking tape is also handy for the job. An 'L'.

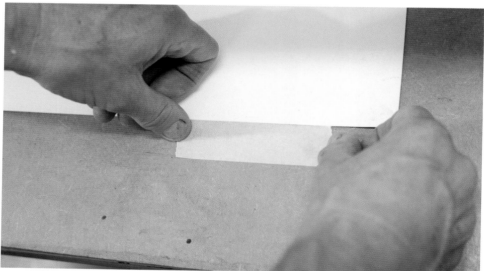

A bar along the bottom edge.

All this registration process has taken some time, and by now, your ink may well have dried in the screen and you are very likely to be experiencing the first common angst of the screen printer – blocked mesh!

Remove the printing paper, place a sheet of newspaper underneath and clean the ink through the screen onto the newspaper below, working the ink through using the damp sponge. Change to a fresh piece of newspaper and use the damp sponge once more. Chuck the newspaper away. That should do the trick. DRY thoroughly with your precious dry cloth. It is worth getting efficient at the cleaning process as it makes printmaking much less messy and daunting.

There's one last task before starting to print.

Draw a pencil cross in the bottom left corner of the printing paper and a pencil line next to the side registration mark.

REGISTERING DECKLE-EDGED PAPER

If your paper has deckle edges they will never register completely accurately if registered by the corner and bar method. Maybe you don't mind. A bit of mis-registration can look good, and reminds the viewer that this is a hand print, not some precision machine print. Happy printmakers are ones that embrace these little quirks.

Some people cut a short piece of deckle off at the registration corner and along the side. Or, you can cut a tiny 90 degree nick in three places and set your registration marks to slot in to those nicks.

All this needs a lot of tedious pre-printing preparation. I suggest it's easier to use the sheet of acetate to register each individual print, and use the registration marks as a guide.

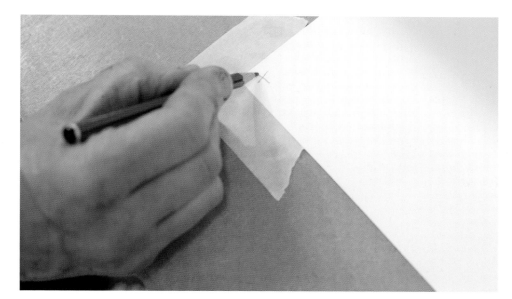

Place a pencil cross in the corner you are registering to.

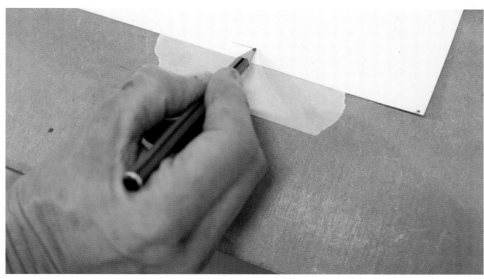

Place a pencil line next to the side registration mark.

Always register to these marks. This will make more sense later on, and is especially important if your first stencil is a rectangle. It is very difficult to see which way round you printed it on the paper. The marks can be erased at the end.

PRINTING

At last you are ready to print! You print by pulling the ink towards you across the stencil. Then you have to get the ink back to the top. This is called 'flooding'. Always remove the print and lift the screen up to flood. Some screen beds have a handle to help you with this.

Get into the 'print routine':

1. Flood screen
2. Place printing paper
3. Print
4. Remove and rack the print
5. Flood screen.

It is a good idea, when each image has been printed, to leave the mesh with a full flood of ink on it while putting the print in the rack or taking time to assess and admire it. This will prevent the ink from drying in the mesh. That is why this print routine starts and ends with 'flood screen', just to make sure.

Start by checking that you have some paper in place (many a fine print has been printed onto the surface of the bed!). Spread the ink along the edge closest to you.

Make sure you have enough to get across to the other side, more rather than less. Now here's the tricky bit...holding the

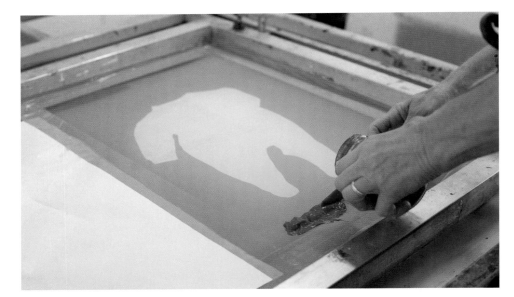

Place enough ink to get to the other side and back.

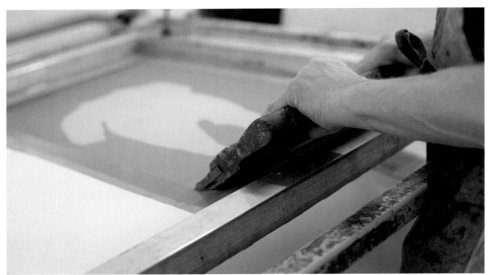

You can hold the screen up against your stomach.

screen up, so that it doesn't touch the paper, and *keeping the correct angle* with the squeegee, flood the screen by pushing the ink across to the furthest side. Many printing problems arise from not keeping the same angle when flooding back; for example, too thick ink squeezing out over the edges, or strange marks and fluctuations in the next pull of ink.

Use enough pressure to sweep across evenly.

Lower the screen ready to print. Again check your printing angle. Gather all the ink. Check your pressure is even.

Print by pulling the squeegee towards you with nice even pressure and the correct angle.

Swiftly lift up the screen and remove your print to the drying rack

Place the next piece of paper in position. Repeat. Keep up the process. Don't stop to admire your work at this point, as the ink can quickly dry in the screen.

PRINTING PROBLEMS

IMAGE TOO THICK OR INK BLEEDING

Check the squeegee angle, is it too acute? Or are you pulling with too much force, possibly bending the rubber blade? Make sure the angle is consistent across the whole sweep and that you are using even pressure. Check your snap (the gap between the mesh and the screen); it should be 4 to 5mm.

THICK EDGES TO PRINTED IMAGE

The image has been placed too close to the edge of the screen. Always leave a border of at least 5cm.

Flooding, taking care to keep the right angle constant across the whole mesh.

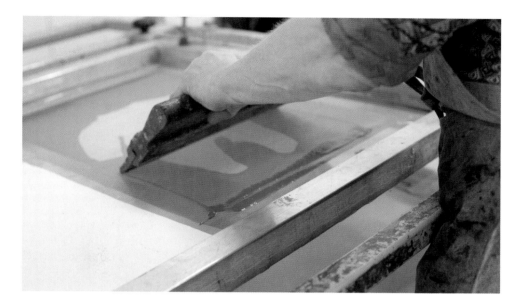

Print; by pulling the squeegee towards you with nice even pressure and the correct angle.

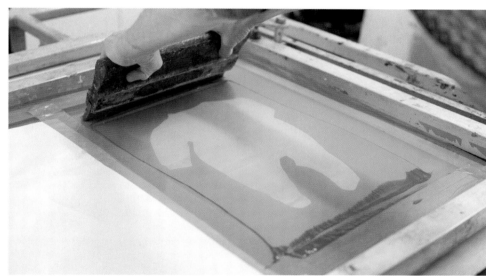

Pull steadily towards yourself.

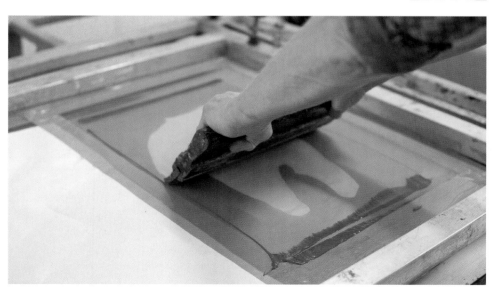

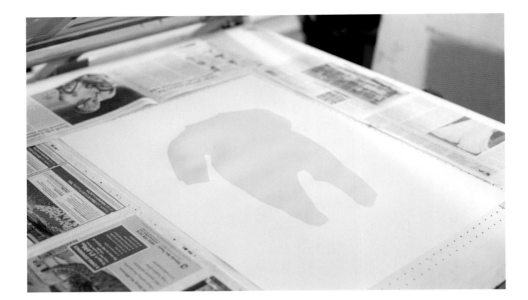

Swiftly lift up the screen and remove the print to the drying rack.

PRINTING WITH A FIXED ARM SQUEEGEE

If you have a screen bed with a fixed arm squeegee holder, you can plan larger prints. The arm goes from side to side across the screen. Fix the squeegee in the middle so that it hangs horizontally when you lift the arm a little. This will ensure even pressure. The same 45 degree angle is essential. If need be, adjust the regulating buffers to change the angle of the squeegee.

The same 45 degree squeegee angle is necessary for printing when fixed to the arm.

INK DRYING IN THE MESH

You may be taking too long a break between pulls, don't stand around admiring your work yet. Or there may not be enough medium in the ink. A 50/50 mix is best.

INK MARBLED OR BITTY

Spend time mixing your ink really well. Dry acrylic paint has a nasty habit of getting into the ink, maybe from a crust around the edge of the jar. Clean away the inside rim of the jar or, if the ink is too old and clotted, throw it away and start afresh. Have newsprint close by to pull several prints on until the ink is clean and behaving itself. Try again. It just takes a bit of practice and you'll soon be printing perfectly.

CLEANING UP

To change colour and print this same stencil in a new colour, scrape up all the ink on the screen and replace in the jar.

Scrape up all the ink.

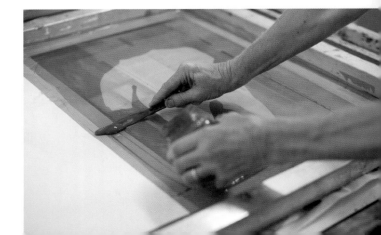

Place a sheet of newspaper underneath.

Clean the ink through the screen with your wet sponge onto newspaper below.

Change to a clean sheet of newspaper and wash through again. Dry completely with your dry cloth.

Clean the squeegee blade, firstly by scraping the excess ink back into the jar, then washing with a sponge and water.

Dry thoroughly. If you have completely finished printing this stencil and don't want to use another colour through it, then remove the screen from the bed. First, scrape up all the ink on the screen surface and replace it in the jar; it will last for months if the top is kept on. Remove the screen from the printing bed by loosening all the screw handles and clamps. Take it to the wash-out area. Rinse it with a water spray quite quickly.

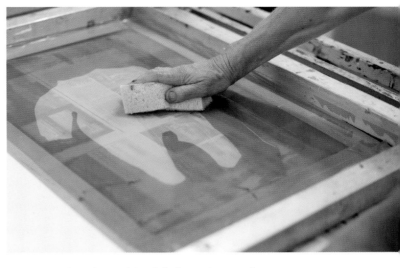

Always clean by pushing ink through onto the newspaper.

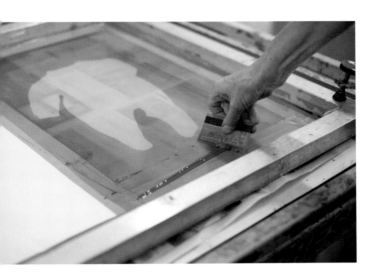

An old credit card is a good tool for this.

Use your invaluable clean cloth to make sure mesh is completely dry.

Place newspaper under the screen.

Scrape as much ink as possible back into the jar.

Don't forget to wash the squeegee.

REMOVING THE STENCIL

Remove all the parcel tape.

Wearing gloves, cover the screen on both sides with *stencil remover*, using a designated cloth or brush. (It can be a good idea to have the stencil remover in an atomizer.)

You will see the stencil emulsion changing colour. Be vigilant, do not leave the stencil remover on for more than a few minutes. If it starts to dry again, it will harden and be very difficult to remove. Wearing goggles and an apron, wash off the stencil with cold water. You will probably have to complete the clean up using the power washer. For this, wear apron, goggles and earmuffs.

Don't start the power washer spray with the nozzle aimed at the screen, it could break the mesh. Always play it onto the sink wall first. Spray evenly and thoroughly keeping the nozzle about 10cm distance from the mesh. Hold the dry screen up to the light to check it is all unblocked

If you can't get your screen clean this way, you may have to use Alkaline Cleaning Paste. Take great care with this chemical as it is very caustic. Use a breathing mask, gloves, goggles, apron. Apply the paste with a brush over the whole screen. Leave for about forty-five minutes. Wash off with a gentle spray of water. *WARNING* – Alkaline Cleaning Paste is very caustic. Always use gloves, goggles, mask and an apron.

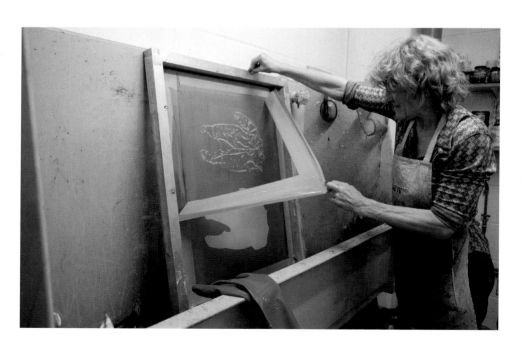

Remove all the parcel tape.

Wear gloves.

Apply stencil remover to both sides of screen.

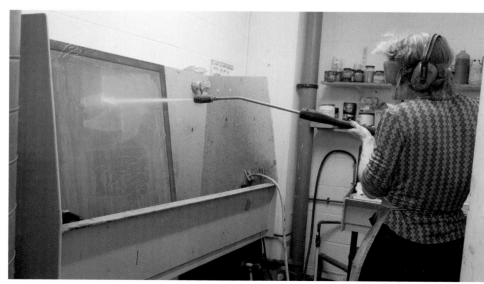

The high pressure jet will remove even tough blockages.

BLENDS, MONOPRINTING, PAPER STENCILS AND MORE IDEAS

Screenprinting is much more engaging and fun when you bend the rules. Rather than print each stencil in one colour, you can daub colour around the surface of the image, or put different dabs of colour on the edge to squeegee across.

As seen in Chapter 4, you can combine monoprinted layers with traditional one-colour stencils.

BLENDS

These are sometimes referred to as 'rainbow pulls'. You can use a blend on any shaped stencil. Or you can start with a plain rectangle.

Mix several pots of printing colour. Try using one jar of uncoloured printing base as this gives a lovely illusion of the colour fading away or being caught in bright light.

Method

Have several sheets of printing paper handy as it takes a few pulls before getting a soft graded effect. Place the inks on the edge of your printing area.

Flood the screen. At this stage the colours are in precise stripes. Holding the screen up, pull towards you without printing so you are just merging the inks on the screen surface. Try putting a bit of wobble on the squeegee as this will merge the

In this blend of dark red, white and yellow, uncoloured printing medium forms the middle band creating a glowing stripe.

colour borders quicker. Flood back to the top and print. The colours will still be fairly sharply separate, so keep flooding and printing until the stripes of colour have blended softly together. This is such a satisfying process once the blend begins to look soft and organic.

OPPOSITE PAGE:
Maggie Jennings, *Pink and Yellow Triangle*. Layers of freely painted translucent inks and paper mask.

Place the inks on the edge of the screen.

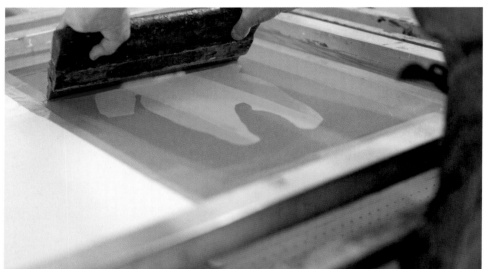

With screen raised, flood mesh with colour.

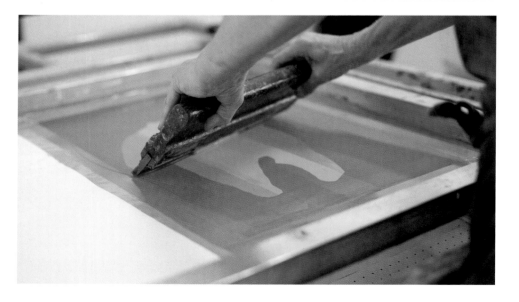

With screen still raised, move ink back and forth a few times across the screen, putting a bit of wobble on the squeegee so edges start to blur.

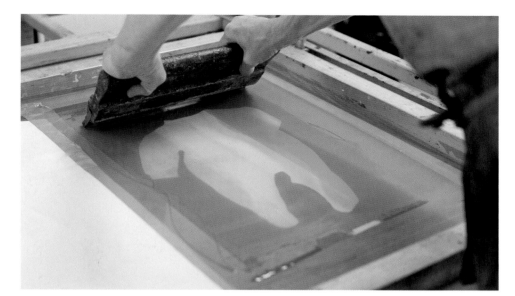

Lower screen and print.

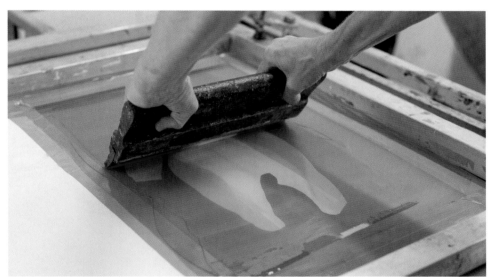

Keep the squeegee angle constant.

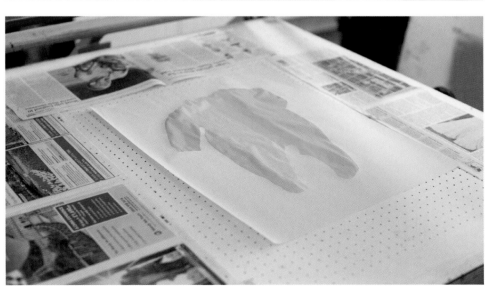

The stripes on the first print will be a bit sharp.

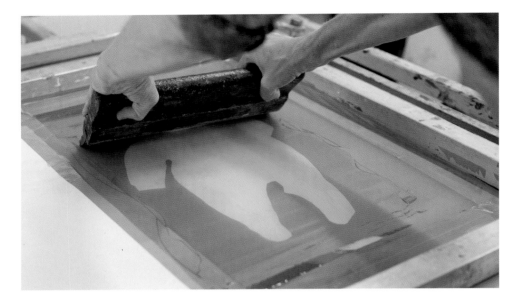

Quickly place another sheet of paper and print again.

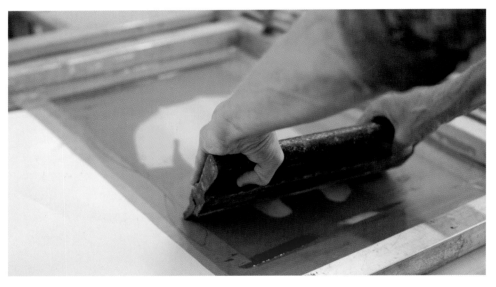

Wobble the squeegee a bit.

The blend is much softer already.

A blend looks great combined with straight stencils

In Jane Grey's image *Morocco*, the yellow blend gives the sky a spectacular beam of light shooting up behind the stencils for the buildings. Another more subtle pink blend on the left adds a further rich glow. The blend of colours in the sky are just one layer of ink on the white paper; they have a translucency. The buildings are overlaid and appear denser.

In this work in progress, Niall Kirk uses several layers of blended applications of colour in the background to build up an organic landscape for the main photocopy stencil, which will be printed later. It is often necessary to turn the print round through 90 degrees and pull the ink in the required direction. The artist has also used talcum powder to achieve unusual effects. See below in 'other effects'.

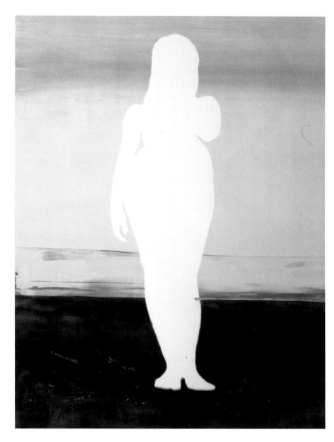

In Jane Grey's image *Morocco*, the sky has a spectacular beam of light from the blend.

In this work in progress, Niall Kirk uses several layers of blended applications of colour in the background.

Niall Kirk, *Afrodite 1*. The various layers of blend give an organic-feeling setting for the main photocopy stencil.

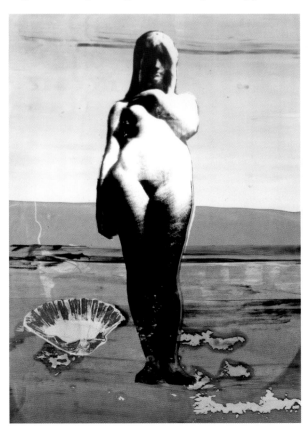

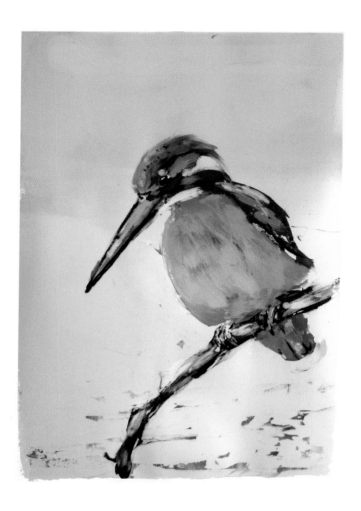

This translucent blend is used as a first layer background for a monoprint. *Kingfisher* **by Maggie Jennings.**

This translucent blend of yellow and grey/taupe is used as a first layer background for this monoprint, providing a soft, seemingly distant perspective. The second printed layer is the painting of the kingfisher, which is then surrounded by transparent medium to allow layer number one to show through. The artist has then ensured that the white areas on the kingfisher are mixed of opaque white paint, rather than the transparent mix using extra printing medium. The random 'mistake' marks at the base where the kingfisher-coloured inks have bled through the transparent medium, resemble reflections and ripples in the water that the bird is perched over. *See* next section 'monoprinting'.

MONOPRINTING

Monoprinting means a one-off image, i.e. 'mono', made with printing techniques. There are many ways of monoprinting using different print techniques. This method of screen-monoprinting is less well known.

The complete image is painted onto the screen and printed through. So why not just do a painting straight onto paper? Hopefully, as a printmaker, you will already have understood the answer to that. There is a special quality to the marks made in printing. As mentioned in Chapter 1, screenprinting allows only the thinnest layer of ink onto the paper, preserving the luminosity of the colours. The speed required to create this type of screen-monoprint promotes a spontaneity and vivacity. Decisions must be made quickly and irreversibly. You will be totally immersed in the moment. After all the quotidian chores of setting up to print, it is thrilling to have the freedom to produce complete images in a matter of minutes. It is a fascinating balance between intention and chance. Use monoprinting as a speedy and liberating way to work through your ideas.

Each colour and shade is a separately mixed ink. So, for example, in the image *Hoopoe in the Land of Rocks*, seven separate coloured inks make up the flower. The sky is also printed simultaneously with all the other colours.

Method

To simply and swiftly make a rectangle through which to print, use parcel tape. Make the rectangle a bit smaller than the squeegee you are about to use. Cover the rest of the screen with newspaper or, preferably, some shiny paper that allows the squeegee to slide freely. Brown wrapping paper makes a good cover.

Spend time mixing a full palette of colours. It is a good idea to have different translucencies of the same hue, for example, a very transparent blue and a full strength mix of the same blue.

GETTING ORGANIZED

It is important to get yourself organized right from the start, then the whole monoprinting process becomes less frantic and messy. The screen is not designed to have so much ink sploshing around on its printing surface and you may find the ink squeezing out under the borders. This is something you may just have to put up with. You can quickly waste a large quantity of ink as it all ends up in a murky-coloured slick. So learn to use as little ink as possible. Place your squeegee in the same resting place between pulls to keep it clean. *Follow* the directions in Chapter 5 'Having Everything To Hand' for setting up all you need.

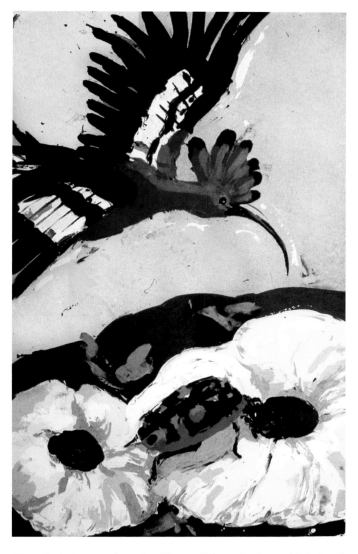

The whole image of maybe fifteen different coloured inks is all painted in one go. The colours are vivid and clean. *Hoopoe in the Land of Rocks*, Maggie Jennings.

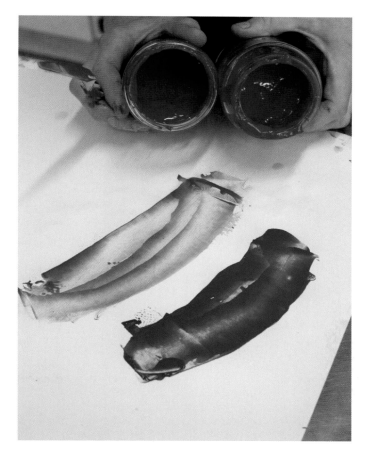

The same blue has been mixed with different amounts of base to make pale- and full-strength blue.

Have all the colours and shades that will be needed ready mixed before starting as there is no time to stop once printing has begun. Start with at least five colours. As you get more ambitious, you may want to use up to twenty. Remember, one 'colour' can be the uncoloured medium. Use the medium to make colours paler. As mentioned in Chapter 6, be aware that using white to lighten the colour changes the look of the colour. Also, have at hand an empty pot for scooping the waste colour into.

If possible, work with polythene or plastic palette knives. Using a palette knife will allow you to scrape on the required minimum amount of ink needed to fill the mesh. Any ink standing up proud of the mesh will be dragged down with the squeegee making a mess and ending up wasted.

Old credit cards can be cut into shapes for applying the ink. Use brushes to flick ink and paint the design, but leave ink standing proud of the mesh.

Once all the pots of colour are mixed and ready, place them on a workspace nearby. Place a sheet of printing paper under the screen (sadly, many a fine print has been done directly onto the screen table). Place the squeegee, or a block about 2 to 3cm high, under the edge of the screen to prevent the mesh from touching the paper as you paint the image. Have your work-book or master drawing in view, or your idea ready in your mind. Start to apply ink to the mesh. It is important to start with the details. What fills the mesh first is what prints. Ink placed over the top of what is already there does not show. It is a bit like painting on glass. For example: if you were to paint a face, the pupil of the eye is applied first, then the iris, then the white and lastly the face.

Put the smallest smear of colour onto the surface, trying to just fill the mesh without leaving big blobs of ink standing proud. The whole surface of the screen must be filled with ink. Use the transparent medium to fill in blank areas. If a gap of mesh is left un-inked, when the squeegee is dragged across,

This is what happens if you don't fill in every bit of the mesh with ink. *Turnips*, Maggie Jennings.

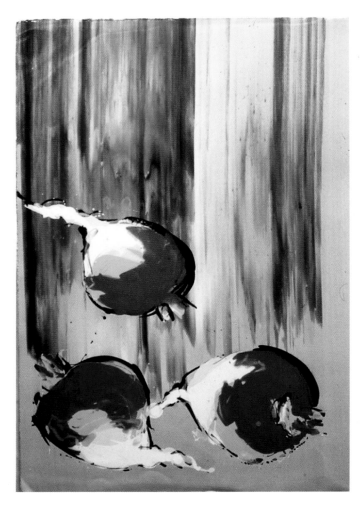

Turned the image around and it becomes *Turnips From Heaven*. By Maggie Jennings.

the rest of the ink will get dragged through the gap to leave a stripy smear.

It should take no longer than fifteen or twenty minutes to paint a monoprint like this. If too much time is taken, the first inks on the mesh may dry in. Use clear medium spread on top of the first marks to keep them fresh while you finish the design.

As you can see in the image of *Turnips*, the turnips were painted using four colours and black, used as a line. The rest of the mesh was left empty. The blue ink was placed at the top of the mesh and squeegeed through. As the squeegee travelled down the screen it collected all the colour and deposited it in a smeary stripe in the empty mesh. However, you might find you like this 'mistake' and want to use it in your image. Turn the image around and it becomes *Turnips From Heaven*.

Once the image is painted, remove the squeegee or spacer block from under the edge of the screen, take the squeegee to the top edge, and print. Here is your complete monoprint.

The first mark to touch the screen will appear in front. A palette knife is a good tool for applying the small amount of ink required just to fill the mesh.

Marks can be flicked on, but will likely smear in the printing.

Using clear medium and polythene palette knife to cover the background where you want it to stay white.

A brush can be used to apply marks.

Ink standing proud of surface will spread and smear. With practice you can vary your hand direction to apply ink.

Try to use the ink thinly.

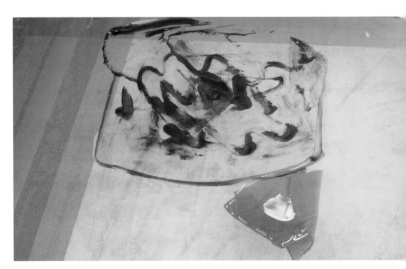

The medium secures the inks in the mesh.

Different translucencies of blue.

In the bottom-left hand corner you can see that all the inks that have gathered on the squeegee have smeared through where the mesh was left empty.

The bottom left corner has been left empty with no ink at all.

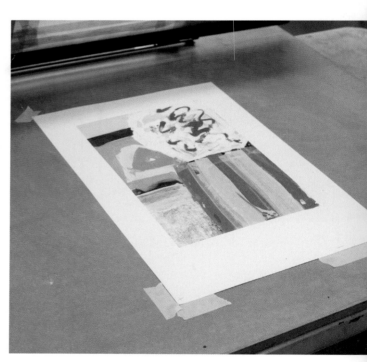

The whole image has taken about fifteen minutes to produce.

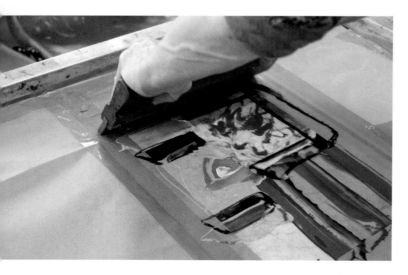

Pull steadily at the correct squeegee angle.

USING THE AFTER-IMAGE TO CREATE A SECOND MONOPRINT BASED ON THE FIRST IMAGE

If you are swift and organized, you can probably do one more print without cleaning off, using the after-image on the mesh, but remember it dries quickly in the mesh. If there are already white bits on your print where the ink has dried in the screen, wash immediately. *See* Chapter 7 'Cleaning Up'.

To do a second print, place a sheet of printing paper below and apply ink as before. Areas of screen can be protected and saved by using clear medium. By saving some areas and varying others, a richer and softer image can be achieved.

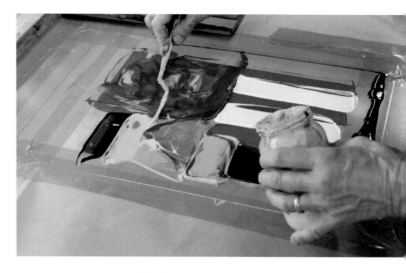

Completely cover the mesh.

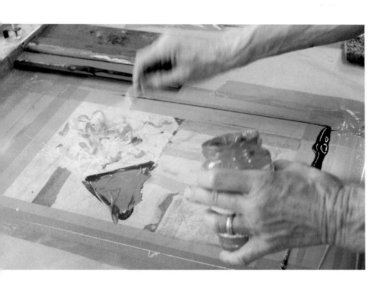

Varying the marks slightly.

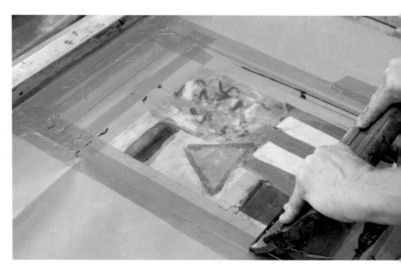

Pull through.

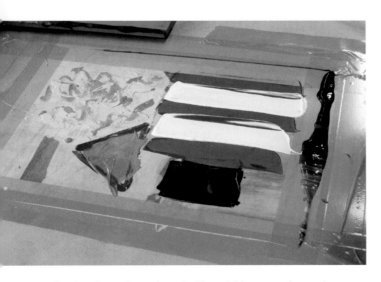

Strokes from the palette knife quickly cover the surface.

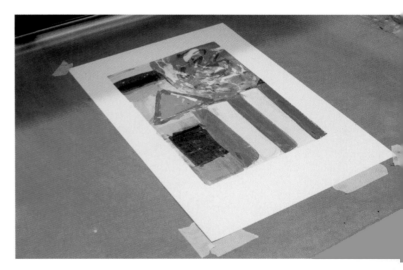

Remnants of the last print left in the mesh give a softness to the marks and added depth to the colour.

MONOPRINTING AGAIN OVER MONOPRINT IMAGE NUMBER ONE

Layers can be built up on your monoprint. Let the first layer dry (probably about fifteen to twenty minutes), then place the print under the screen again in the correct position. You can see through the mesh to your image. It is important to place the squeegee or a prop to keep the screen from touching the paper. To protect areas you want to keep, first scrape uncoloured printing medium over that area, then paint wherever else you wish.

Clean up promptly when monoprinting. It is easy for ink to dry in the mesh and then drastic action may need to be taken to remove it.

Clean promptly. Always clean through onto newspaper.

Scrape up the remains of the ink. Sadly these are often unusable unless you like using grey.

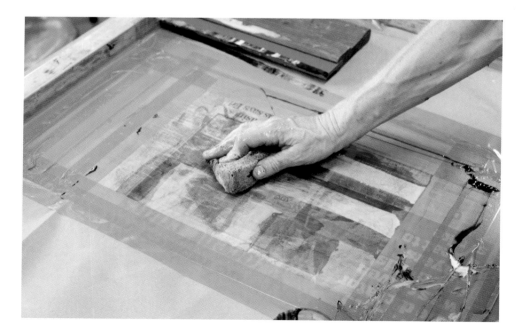

Quickly wash mesh with a sponge or cloth.

Let the print dry, with more layers it takes a little longer, then you can print on it again. Newsprint masks can be used to block out areas protecting the previous image. After pulling through, peel off the newsprint mask. It usually looks great. Perhaps it can be used to collage onto the next print.

Place print under screen.

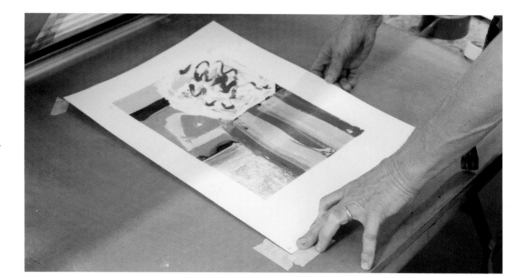

Use newsprint to mask out areas when printing over a previous image.

Clear medium is applied to mask out areas.

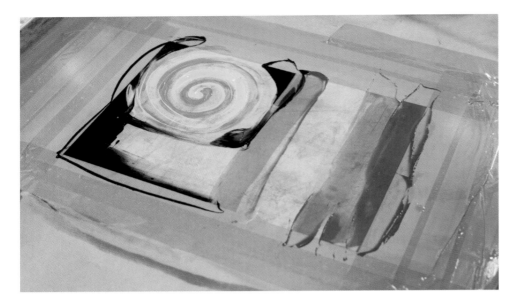

More ink is applied.

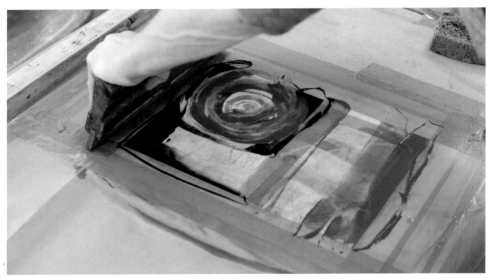

Pull the ink through.

Peel off the newsprint mask.

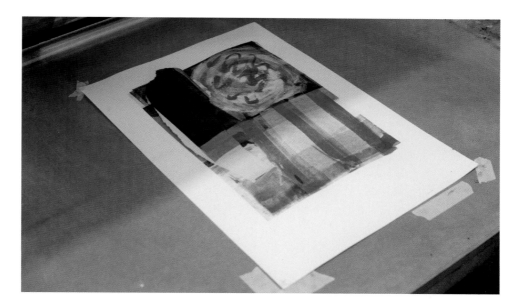

The translucent colours allow the first layer to show through.

Here is a monoprint that has been built up with three layers. Because of the translucency of the printing colours, each layer's marks show through and add a richness and vivacity to the image.

Layer one.

Layer two.

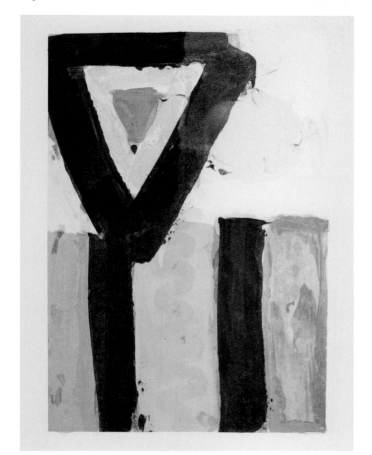

TOP LEFT:
Layer three.

TOP RIGHT:
The newsprint mask is pulled off.

BOTTOM LEFT:
The newsprint mask is collaged onto another print.

In Maggie Jennings' monoprint *The Little Fishes To Thee Swim*, the swimmer and the fishes and the general water colour were done in layer one. The image was printed on again, water effect has been done in this second layer, using flicks and splashes of translucent inks. Some pastels were also used to create some lines. See the next section for monoprinting with water-soluble pastels.

OPPOSITE PAGE:
In Maggie Jennings' monoprint *The Little Fishes to Thee Swim...*, the water effect has been done in layer two, using flicks and splashes of translucent inks.

MONOPRINTING WITH WATER-SOLUBLE PASTELS

Wonderful shimmering crayon effects can be achieved using water-soluble pastels. These are also called 'water-based oil pastels'.

The added benefit of this technique is that there is no rush to complete the image before the ink dries, so you can take your time and leisure creating the drawing. Experiment as to how hard to press with the crayon and how much pastel to push into the mesh. Too thick, and it will just block the mesh. Too thin, and it will be disappointingly faint. Dip the crayons in water as you draw to release the pigment. The more water you use, the more the colours will flow and blend.

In *Yellow Dress* by Celia Normand, the freshness and excitement of the artist's original sketch is recreated here with the use of pastel.

Water-soluble oil pastels.

Experiment with how hard to press, some pigment may block the mesh. Celia Normand, *Yellow Dress.*

98

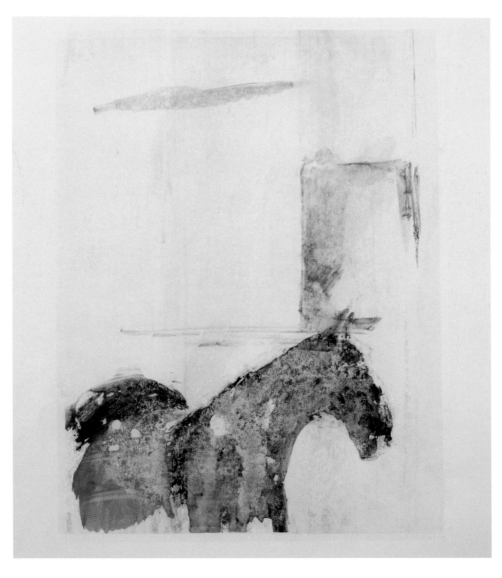

The pastels were dipped into copious quantities of water to achieve this soft watercolour effect. Celia Normand, *Royal Mews*.

In Celia Normand's sensitive image *Royal Mews* the pastels were copiously dipped into water to achieve this soft watercolour effect. The previous image left in the screen becomes a simple and beautiful way of describing the space and light. This method suits artists that enjoy using watercolour. It has a softer and more fortuitous outcome. The main unpredictability of this method is to do with how hard it is to regulate the amount of water needed to release the colours. But, as you can see, there is a marvellous subtlety not always found in other methods of screenprint.

Method

Place your paper below the screen in position before starting to draw. In this instance it is ok to have the mesh touching the paper while doing the drawing. It doesn't matter if the pastel comes through onto the paper, as long as you keep the paper in that position. Dip the pastel into water before making your mark. Different pastels need different amounts of water to release the colour. Take your time making the drawing. There is no rush at all at this stage.

Try different methods of applying the pastel. Tear off the paper and use the side of the pastel as well as the tip. Keep dipping the pastels in the water all the way through. Remember the background. That can be drawn too, or it can be left to be filled with the transparent screen medium.

Once the drawing is complete, place a prop under the screen so that now the mesh doesn't touch the paper. Using clear screen medium, flood the screen backwards and forwards two or three times and let it sit there for one to two minutes to dissolve the pastels further. Remove the prop and squeegee the ink through. If it hasn't released through and the paper is still in position, have another go with more screen medium.

In Nicky Basford's *Andalusian Fields*, drawn lines blend and turn into watery colour fields to create an exciting balance between intent and accident.

In Nicky Basford's *Andalusian Fields* drawn lines blend and turn into watery colour fields to create an exciting balance between intent and accident. Despite all of these marks being created in just one layer, there appears a wonderful diversity from rich density to a joyful translucency.

The range of colours supplied in the box, which are rather similar in tone, limits one slightly, but it is possible to mix them if enough water is used while applying them.

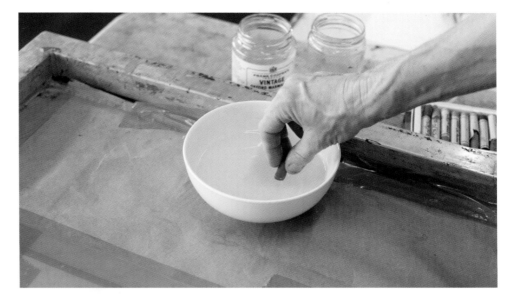

Dip the pastel into water before making your mark.

Take your time making the drawing.

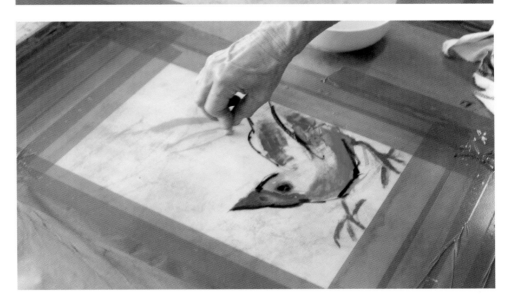

Use both the side and the tip of the pastel.

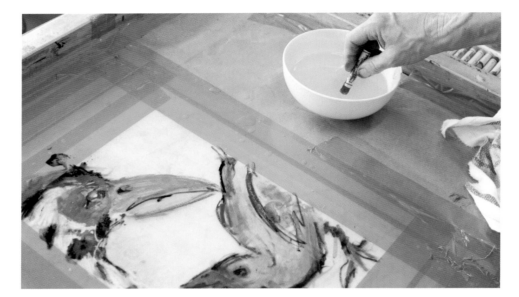

Keep dipping the pastels all the way through.

Fill in the background too.

Use clear printing medium to release the image.

Prop the screen up. A roll of tape is a good height.

Use enough medium to cover the image.

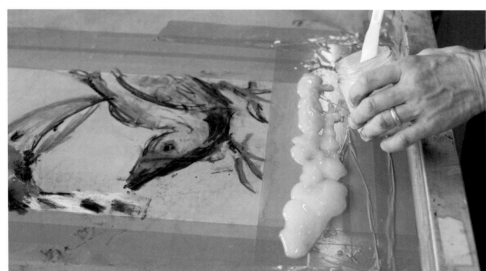

Flood medium across the image.

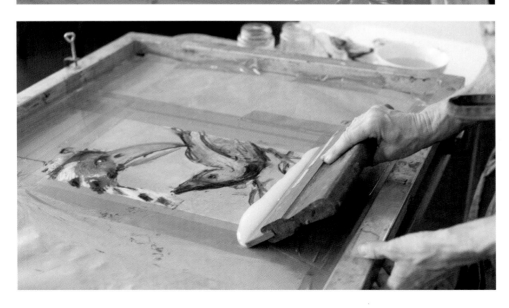

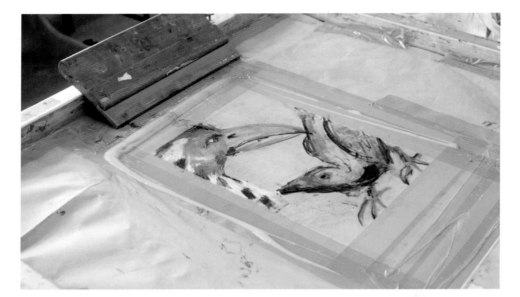

Let the medium sit in the screen for about one minute to release the pastel.

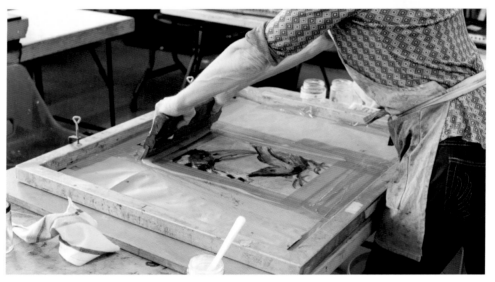

Remove the prop, gather all the medium with the squeegee.

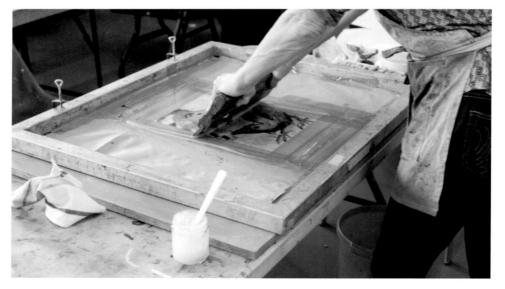

Pull strongly and steadily.

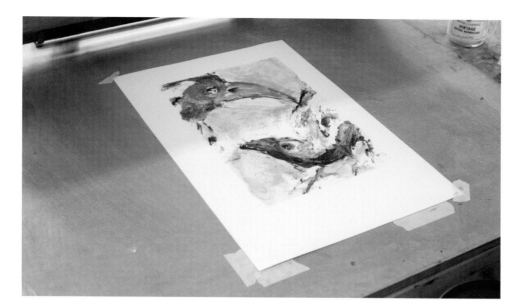

Some pastel remains in the mesh.

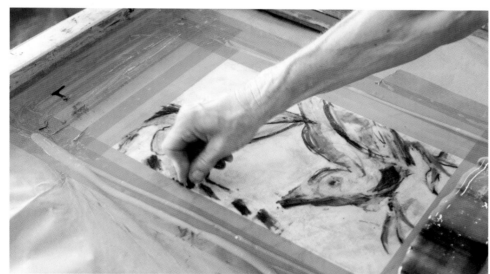

Place another sheet of paper below, draw again.

More pastel has printed this time.

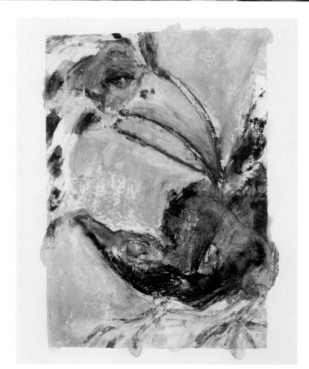

Pastel embedded in the mesh may have to be rubbed hard. Always rub through onto newspaper.

PAPER STENCILS

Making a paper stencil

Stencils can be made without the photo-exposure process. Paper stencils can be torn or cut to mask out areas of the screen. It is nice to have a direct simple method, but be aware that the stencils may not last long. Always use newsprint to create the stencil as it is thin and slightly absorbent so it sticks nicely to the screen while printing.

Cut the newsprint with a sharp scalpel or scissors. Or tear it against a ruler for a soft straight edge. For soft organic shapes, using a fine brush, paint a thin line of water onto the newsprint. Let it soak in for a minute, then gently tease and tear along the wet line. Let the stencil dry before using it.

Sticking the paper stencil to the screen

To stick the paper stencil to the screen, place the printing paper on the bed. Place the paper stencil on top of the printing paper where it is to be printed. Lower the screen and pull through the ink, which will stick the stencil to the mesh. If it is a large stencil and the corners are flapping around, just stick them up with masking tape. The paper stencil should last for many pulls. However, you will need a duplicate stencil if you want to change colour as the paper stencils come off when you wash out the ink.

The *monoprint with paper strips* is done using strips of newsprint to block out the ink. Then the strips are placed at 90 degrees to create a criss-cross effect. Incidentally, see how semi-transparent white ink is used to modify the other colour.

Paper strips as stencil. **This print is done using strips of newsprint to block out. Then the strips are placed at 90 degrees to create a criss-cross effect. See how semi-transparent white ink affects the colours below.**

You can review your old work and print on it again. To change a section of the image, cover the rest of the image with newsprint and print over the required section. Here a previous monoprint is being altered.

Black will usually cover up well and can be a dramatic way to introduce a new shape.

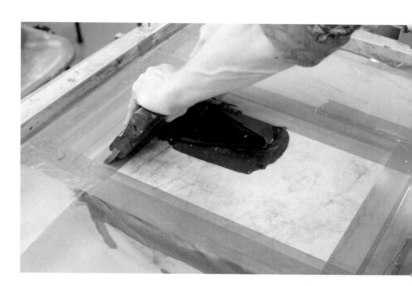

If you don't like a section of your image, cover the rest up and print over again.

Black usually covers up well.

Three layers of monoprint. The top right corner was worked separately.

In Ian Scaife's striking four-colour print, done entirely with paper stencils, he will plan to print a dark blue on top of a light blue, but will make sure the red goes straight onto the clean paper for full-colour impact.

In Ian Scaife's striking colourful prints, done entirely with paper stencils, he will plan to print a dark blue on top of a light blue, but will make sure the red goes straight onto the clean paper for full-colour impact.

In the image *Violet, Pale Blue*, the pale blue is printed across all the image with the exception of the area intended for the red shape which has been masked out with a cut shape of newsprint. This is followed by a darker blue-violet which forms the matching shape to the red, so everything is masked out except for that shape which is printed over the pale blue. Then everything is masked out except for the red shape and the red is printed onto the blank paper. (If you look closely you can see where the red has printed over the edge of the pale blue, slightly varying the colour.) Lastly, the two shapes are masked out while the darker colour is printed, as shown on the print on the printing bed. The newsprint lying above shows the proof of this final stencil before it is printed onto the image.

The just completed print, and showing the artist's working area with a proof of one of his paper stencils.

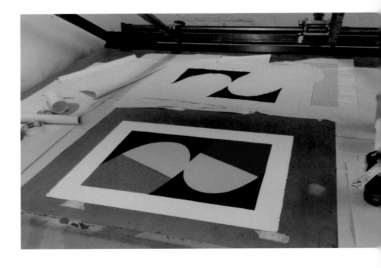

Diagram of printing order for *Violet, Pale Blue*, by Ian Scaife.

OTHER EFFECTS

Chalk or Talc

Sometimes the screenprinted ink feels too regular, even and flat. For strange and organic effects, try shaking chalk or talcum powder onto the paper waiting below. When the ink is squeegeed through it will create random textures which last for a few pulls.

In Niall Kirk's *Owls,* the strange compelling textures in the background that echo owl feathers are created from talcum powder on the paper below as it is dragged along by the weight of the squeegee and blocks the mesh.

Powder or Glitter Thrown onto Wet Ink

In Christina Neiderberger's striking *Chandelier* print, as soon as the image was printed and the ink still wet, light reflecting beads were thrown into the still sticky image. As the viewer moves position, so the light-reflecting beads catch the light fascinatingly.

Experiment with metal powders too. Gold, silver and bronze powders are effective. Cheap glitter is fun too.

Showing how paper stencils are planned for other prints. Holes cut in the paper create the stencil, placed ready to pull the next colour.

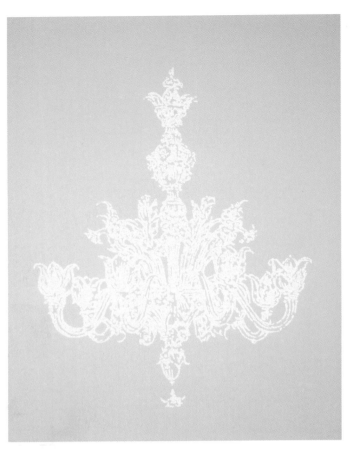

In Niall Kirk's *Owl*, chalk or talcum powder has been scattered on the waiting paper before printing. This has given a random organic texture to the printed ink in the background that echoes the owl feathers.

As soon as the image was printed and the ink still wet, light reflecting beads were thrown into the still sticky image. Christina Neiderberger, *Chandelier*.

An image worked on in Photoshop has had play-glitter stuck on after printing. Maggie Jennings, *Allistair*.

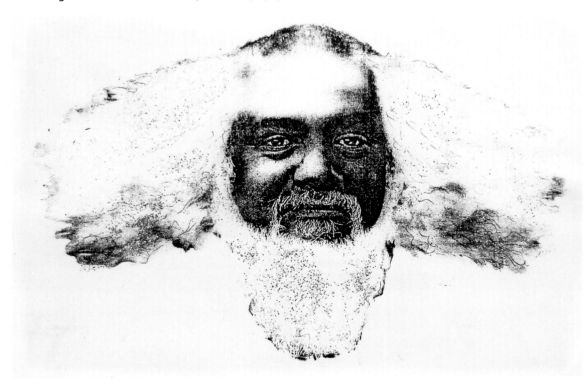

Chika Ito, *Gold Waves, Silver Waves.* Printed with ink made with rice flour, beet juice, and red cabbage. The prints were then made into an accordion-fold book.

Chika Ito, *We Share The Same Sky* was printed with ink made with wheat flour and red cabbage then made into an accordion-fold book.

An image worked on in Photoshop has had play-glitter stuck on after printing. *Warning – wear a mask and goggles when using powders and dry pigments.*

Printing with Unconventional Materials

All sorts of things can be mashed up and squeezed through a mesh. It would be best to get a courser mesh screen designed for fabric printing. Try mashing fruits and vegetables or put them in a blender, then through a sieve. Make a starch paste, wallpaper paste does very well, or make up a paste with traditional rice starch. Add mashed or juiced plants to the paste and squeegee as normal. You may have to experiment a bit to get the correct consistency. Some colours made from plants may not last for long. They could change or fade after a few years.

Chika Ito prints using colours from plants mixed with starch paste. *Gold Waves, Silver Waves* was printed with ink made with rice flour, beet juice, and red cabbage. She made these beautiful prints into an accordion-fold book.

Chika Ito's *We Share The Same Sky* was printed with ink made with wheat flour and red cabbage and this was also made into an accordion-fold book.

Mixed Media and Collage

Screenprinting is an efficient way of producing multiples, so you can easily print plenty of extra prints for trying out different ideas. Keep your proofs and rejects. Cut or tear them up to use in new work.

Marie Coccolatus keeps old prints and trials to re-use in

Marie Coccolatus keeps old prints and trials to re-use in further works.

A piece collaged into a mixed media print in conjunction with collagraph textures. Marie Coccolatus.

further works. Screen printed marks from previous prints are cut up and collaged into a mixed media print in conjunction with collograph textures.

Esther Sunyer Parellada prints her large selection of images on many different surbstrates, then cuts and collages and re-assembles them, often printing again over these collages. Every image takes a new direction, engendering new ideas from the original material. Each print has a new identity.

In Penny Mundy's engaging series of *Needlework* prints, the elements of the design have been printed on different surfaces including Japanese tissue paper and fine fabric. These have been actually sewn onto the final paper image, along with a

Esther Sunyer Parellada prints her large selection of images on many different substrates; then cuts and collages and re-assembles them, often printing again over these collages.

In Penny Mundy's series of *Needlework* prints, the elements of the design have been printed on different surfaces including Japanese tissue paper and fine fabric. These have been actually sewn onto the final paper image. Photocopies of pins, needles, ribbon and scissors confound the eye.

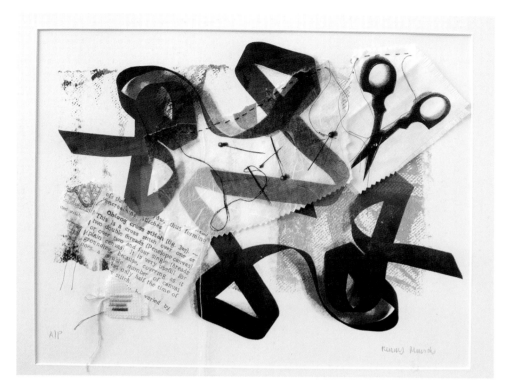

small sewing sampler. Photocopies of pins, needles, ribbon and scissors confound the eye when placed alongside actual elements like the sampler.

Jairo Zaldua and Nicola Green have used screenprinting in their site-specific collaborative works. They like the malleable and tactile quality of paper and the way it absorbs ink. For *Fragments* they printed onto thick lining paper, which was also torn and shaped appropriately. Screenprinting has been chosen due to its flexibility and immediacy. They will even take a screen onsite, using any flat surface as a printing bed.

They find that screenprinting also lends itself easily to the combination of other media such as digital art, sculpture and installation, and the materials are portable.

Jairo Zaldua and Nicola Green have used screenprinting in their site-specific collaborative works. They will even take a screen onsite, using any flat surface as a printing bed.

For *Fragments*, they printed on thick wall lining paper, which was torn and shaped. (Performer: Gigi Gianella; photo: Katsua Isobe).

Ian Scaife, *Red Zappa*. A striking four-colour print, done entirely with paper stencils.

PRINTING AT HOME WITH A KIT

Simple home printing kits for printing on both paper and textile are available from art and craft stores. These kits allow you to paint images directly onto the screen. It is a positive way of working which means that whatever you paint on the mesh will become the print; what you paint is what you get.

To make colour fields it is easy to make newspaper masks with holes cut or torn in the sheet of newspaper to allow you to print colour shapes. This is usually best done first, before the painted image.

EQUIPMENT NEEDED

There are different kits available. They all contain the basic equipment to get you printing. The main difference is that the expensive ones will supply a base board onto which the screen is attached with hinges. This makes printing considerably easier and means you don't need a partner to hold the screen for you while you print. The kit we use to illustrate this chapter is a cheaper version without the base board and hinges.

All kits should contain a mesh screen, a squeegee, a range of acrylic paints, printing medium for paper, printing medium for textile, drawing fluid, removable screen block and a plastic palette knife. (Although it is called 'drawing fluid' you will apply the fluid with a paint brush, so you might expect it to be called 'painting fluid'.)

A screen printing kit containing a mesh screen, a squeegee, a range of acrylic paints, printing medium for paper, printing medium for textile, drawing fluid, removable screen block, plastic palette knife, paint brush.

You will also need paper for printing on, newspaper for cleaning and for making stencils, brushes, pencil, a craft knife or scalpel, scissors, masking tape and a ruler. An old credit/membership card is handy too for scooping up ink and thinly spreading out screen block. You will definitely need a bucket of water, a sponge or cloth for cleaning and an apron. It is helpful to have a cutting mat for making cut paper stencils, otherwise, use a pile of newspapers or a piece of card to cut on. Don't inadvertently slice into your table top.

For cleaning the screen, access to a large sink or bath is needed as well as washing soda or scouring powder or cream, and a soft scrubbing brush. You could wash the screen out in the garden. There are no nasty chemicals to poison your plants.

Any table can be set up for printing, even the kitchen table.

The main problem with this kit is that the screen is unattached, with no hinge securing it to the printing bed, (in this case, the table). You will need a helper to hold the screen for you while printing.

Determine the size of your image. The image should be at least 4cm smaller than the squeegee blade.

Newspaper tears very easily, so work gently with the sharpest blade you have. In a sheet of newspaper, cut the edges of a shape that will make hole for the colour to print through.

CREATING COLOUR FIELDS

First determine the size of your image. You cannot print too close to the edge of the screen as you will not get adequate pressure. The squeegee is your guide. The image should be at least 4cm smaller than the squeegee blade. If you are using a drawing, make a master drawing at the correct size.

Here a photograph is being used as a guide for the drawing. Draw out the size of the image on a piece of paper.

If you want colour fields in your image, they are best printed first. It is easy to make colour fields using newspaper masks.

Newspaper rips very easily, so work gently with the sharpest blade you have. In a sheet of newspaper, cut the edges of a shape that will make a hole.

This will be the shape of one of the colour fields. Gently tease out the cut shape and discard it. The remaining sheet of newspaper is your mask.

If you want a softer edged shape, paint the shape onto the newspaper using plain water with a fine brush. Let it soak on for a minute. Gently tease out the shape along the moist line.

The remaining sheet of newspaper is your mask.

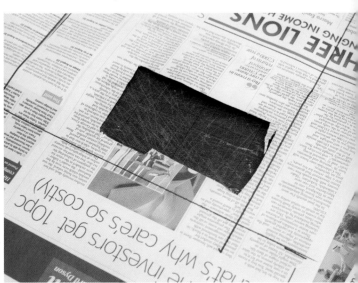

Let the newspaper mask dry for a few minutes.

You can make several different masks. Here we made two separate masks.

The shape is much more organic-looking when torn along a wet edge.

Gently tease the shape out along the moist line.

A second newspaper mask made using a wet brush for a softer edged shape.

Where the edge is still wet, the newspaper mask will need to dry for a few minutes.

The shape is much more organic-looking when torn along a wet edge.

MIXING INKS

See also Chapter 6 on Mixing Colours.

For making a print on paper, make sure you use the correct screenprinting medium, not the textile medium.

Scoop some printing medium into a pot. Add some acrylic paint. For opaque colours add in the proportion of 50:50. However, for colour fields it is often preferable to use a more transparent colour. Use a ratio of about 70 per cent printing medium to 30 per cent acrylic paint. Or for an even more subtle colour try 80:20.

Make sure the ink is well mixed to avoid streaks and marbling effects.

Try out the colour on a bit of paper. If you want to make colour blends (*see* Chapter 8), mix several colours now.

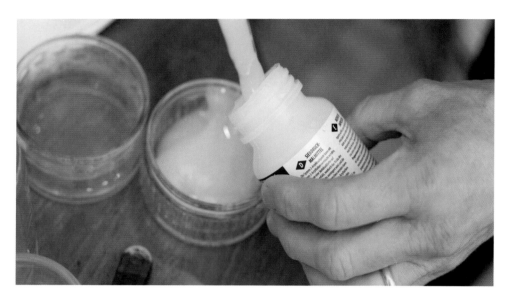

Start with the screenprinting medium.

Add acrylic paint.

Mix well.

Try out the colour on a bit of paper. If you want to make colour blends (*see* Chapter 8), mix several colours now.

SETTING UP THE SCREEN TO PRINT

When printing on paper, the screen should never be touching the paper below except when the squeegee blade presses through. So a gap must be created between the mesh and the screen. This is called the 'snap'.

Turn the screen over with its flat side up. Make some small strips of card about 3mm thick; card from a cardboard box will do.

Using masking tape, stick the bits of card onto the frame of the screen, one at each corner. As there is no hinge to this screen you will have to establish a set place for the screen to sit. Place masking tape as a guide around the edge of the screen as it sits on the table.

Now establish where the printing paper will sit. Measure the borders to get it where you want it. As a guide, it is good to have the top and sides equal, with a little more room at the bottom edge.

Place registration marks at one corner and along one edge as shown (the 'L and bar' method). Take a minute now to go through all your sheets of printing paper and, in pencil, to be erased later, mark an X on the corner to be registered into the L, and a bar next to the registration bar. (For more on setting up and registration, *see* Chapter 7.)

Place the printing paper in register. Place the first newspaper mask on top of the printing paper *in situ*.

Place the screen in place on top.

Make some small strips of card about 3mm thick, a cardboard box will do.

Using masking tape, stick some bits of card onto the frame of the screen.

Stick one strip of card at each corner.

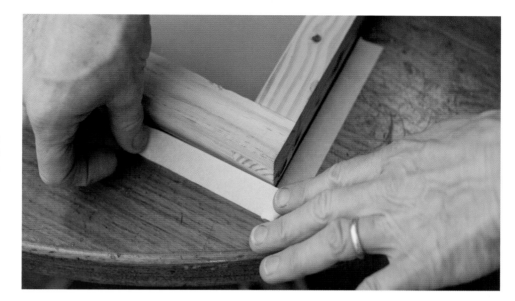

As there is no hinge to this screen you will have to establish a set place for the screen to sit.

Place masking tape as a guide around the edge of the screen as it sits on the table.

Place registration marks for the printing paper at one corner and along one edge (the L and Bar method).

Mark an X on the corner to be registered into the L.

Place the printing paper in register. Place the first newspaper mask on top of the printing paper *in situ*. Place the screen in place on top.

PRINTING

(For more on general printing *see* Chapter 7, and for more on printing with paper stencils *see* Chapter 8.)

This is when you need your partner to hold the screen while you print.

Take the first ink and put a fair amount onto the mesh above the hole in the mask.

The squeegee angle is very important. It must be held at an angle of 45 degrees both for printing and flooding. *Please refer to* Chapter 7.

With your partner holding firmly onto the screen so it doesn't move, pull the ink towards you firmly through the hole and beyond, stopping a bit before the frame.

Lift the screen at your side and flood back to the top. Your partner will have to hold firm.

WHERE TO DRY THE PRINT

The ink dries very quickly on the paper. It could be dry in as little as five minutes, and may probably take fifteen minutes to dry. But the copies do need to be spread out to dry. At home there may be a problem of where to spread them. They could be taped to cupboard and fridge doors and other surfaces with masking tape; if peeled off carefully the masking tape shouldn't ruin the paper. If you have a washing line handy they could be pegged up with clothes pegs. The space under the table is a good possibility. If there are some stairs nearby, put a print on each stair.

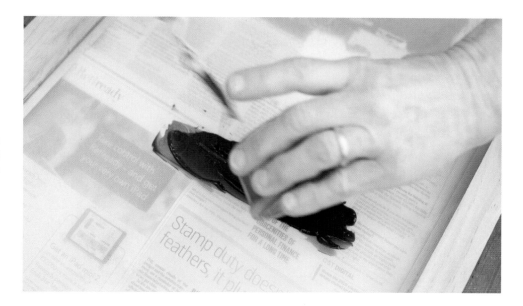

Take the first ink and put a fair amount onto the mesh above the hole in the mask.

Now your mask is stuck to the mesh. If the edges are flapping and threatening to peel off, tape them to the frame at the corners, using masking tape.

Here is your first colour field. It faithfully shows the soft erratic torn edges of the newspaper mask.

Print as many copies as you need now. There's no going back as, once this has been cleaned off, the mask will be destroyed.

Once you've printed all your paper, clean up the ink. Scoop all the excess ink back into the pot. Peel off the newspaper mask, which is now useless, so needs to be trashed. Wash through the mesh onto newspaper with cold water using a sponge or cloth. When clean, dry it with your precious clean, dry cloth. Scrape the ink off the squeegee and wash that too.

Now you are ready to repeat the whole process with the next newspaper mask. Your first colour should be dry now, they don't take long. Get all the prints nearby, ready to be printed on again.

Try using a rainbow blend so that different colours print through different holes in the mask. You can play around scraping colour locally on the mesh. Beware of putting too much colour on. Try always to use the edge of the palette knife. If you lay on colour too thick it will squeeze round the edges of the stencils and bleed over your print.

Here are the two layers of colour field.

Remove the second mask. Clean and dry the screen.

Now for the drawn image.

Here are two layers.

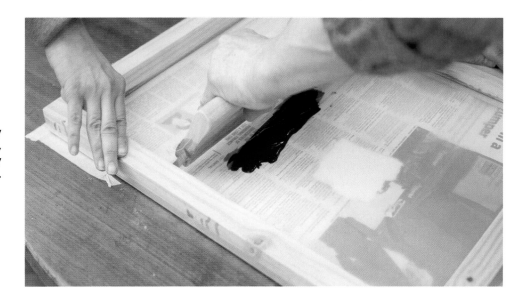

With your partner holding firmly onto the screen so it doesn't move, pull the ink towards you firmly through the hole and beyond.

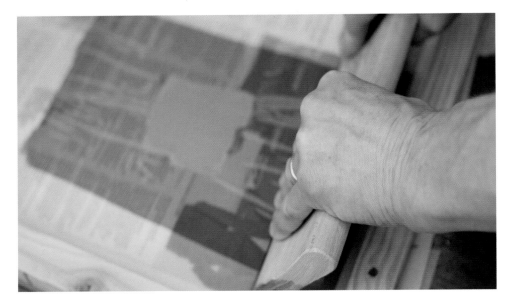

Stop a bit before the frame edge.

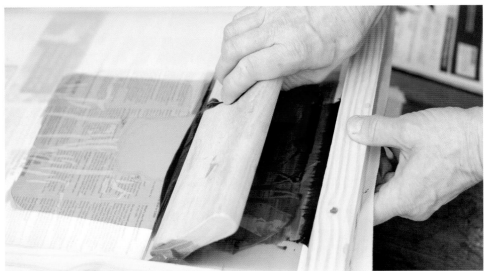

Lift the screen and flood back to the top.

Here is your first colour field. It faithfully shows the soft erratic torn edges of the newspaper mask.

Cleaning up. Scraping up the ink.

Peel off the newspaper mask.

Wash through the mesh onto newspaper with cold water using a sponge or cloth.

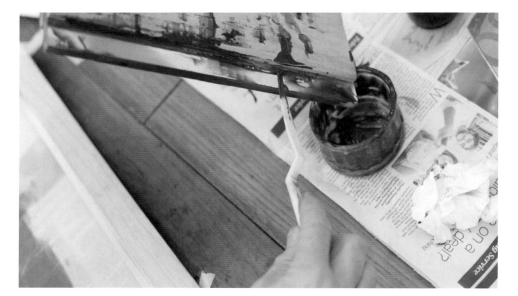

Scrape the ink off the squeegee.

Wash the squeegee.

Using a rainbow blend so that different colours print through different holes in the mask.

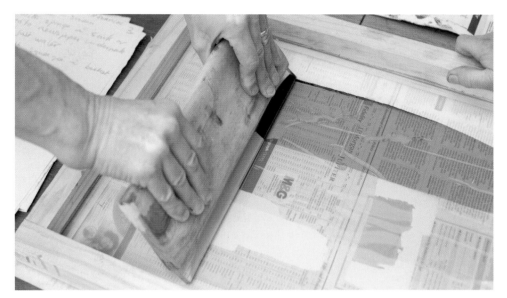

The ink will stick the mask to the mesh.

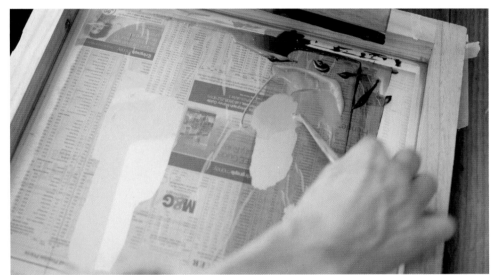

You can scrape colour locally on the mesh.

The two layers of colour fields.

CREATING THE DRAWN SCREEN

Place the screen flat-side down, raised up on props a centimetre or so. You can use the squeegee under one edge, maybe the roll of masking tape under the other. Place your master drawing or image size guide under the screen to show you where to draw the image.

Paint the image using the drawing fluid. It can be diluted with water a bit. Make sure it goes right into the mesh.

You can take your time doing this. If you make a mistake, wash it out with water and start again, but often the first marks are the freshest and best so don't be too precious.

When the drawing is finished, hold it up to the light to check that you have made the strokes strong enough to fill the mesh but, if they're still wet, be careful they don't run.

Put the screen somewhere to dry, it doesn't take long.

When the drawing is dry, prop the screen up again with the screen the same way up as you painted on it. Place a line of removable screen block onto the surface of the mesh as close to the edge as possible. Using the squeegee, sweep the paste across the mesh using a firm stroke. If you have missed a bit, do it again. Fill in any gaps.

By now it may be a bit thick so scrape off the excess with a plastic palette knife or a plastic credit card. Turn the screen over and scrape the excess off the back too. Place the screen to dry.

When the screen block is dry, clean out the drawing fluid with a cloth and water, or you could use an atomizer spray.

Check the mesh for any unblocked areas, especially around the edge. Use masking tape on the reverse around the edge.

Get all your prints assembled ready. Mix the colour.

Set up the screen *in situ* as before.

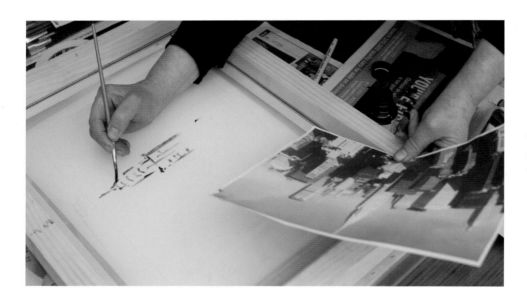

With the screen raised, paint the image onto the mesh with the drawing fluid.

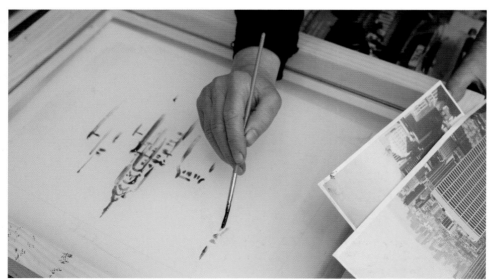

You can take your time doing this. If you make a mistake, wash it out with water and start again.

When the drawing is finished, hold it up to the light to check that you have made the strokes strong enough to fill the mesh.

Place a line of removable screen block onto the surface of the mesh as close to the edge as possible.

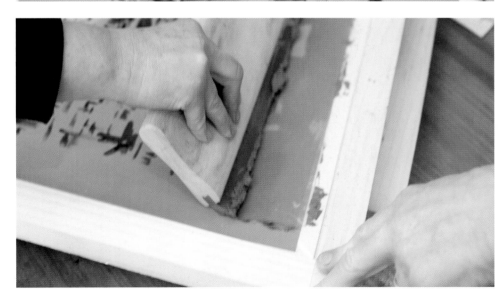

Using the squeegee sweep the paste across the mesh using a firm stroke.

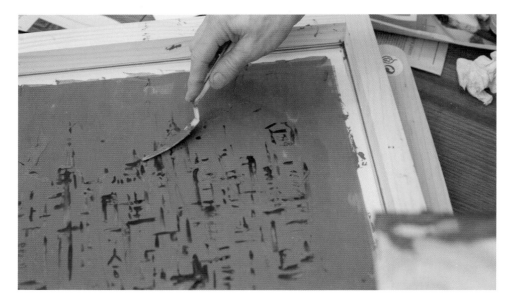

Fill in any gaps.

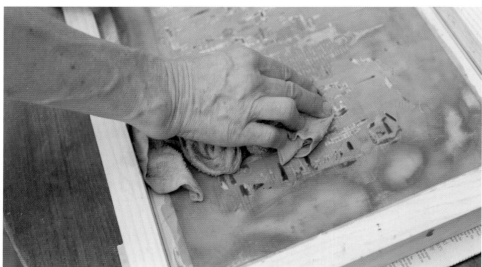

When dry, clean out the drawing fluid with a cloth and water.

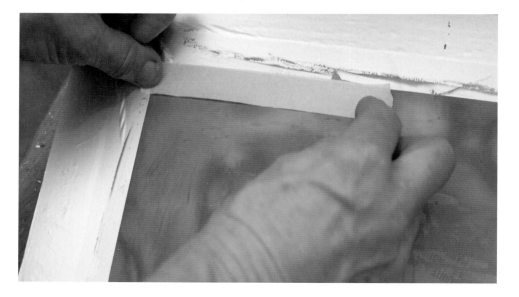

Use masking tape on the reverse around the edge.

Mix the colour.

Flood the screen with your partner holding the screen up for you. Pull the first print onto blank paper to see how it is printing

Now print over your colour fields.

If you want to get even more adventurous, use different colour blends through this stencil too. Be careful not to lay down too much ink on the surface of the mesh or it might bleed round the edges of the stencil. Get used to scraping the *edge* of the palette knife across the mesh rather than the flat of it so as to allow only a thin smear of ink into the mesh.

Don't forget to put a piece of paper in each time, or your print might end up on the table top.

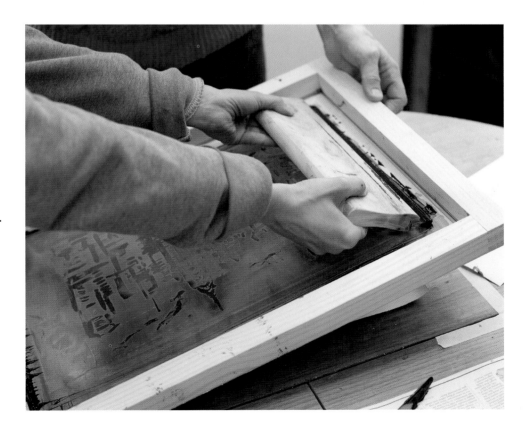

Flood the screen.

Pull the first print on blank paper to see how it prints.

Now print over your colour fields.

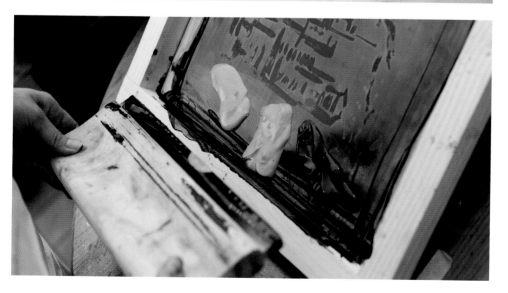

If you want to get even more adventurous, use different colour blends through this stencil too.

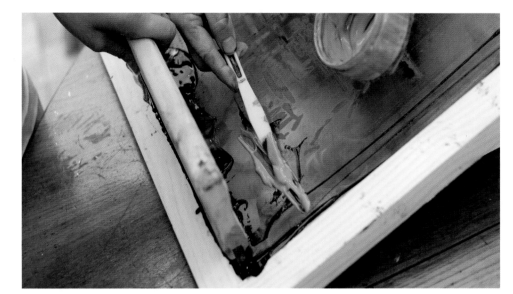

Add colour locally as well.

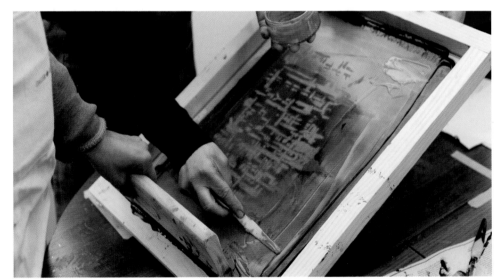

Use the palette knife to smear a thin
layer across the mesh.

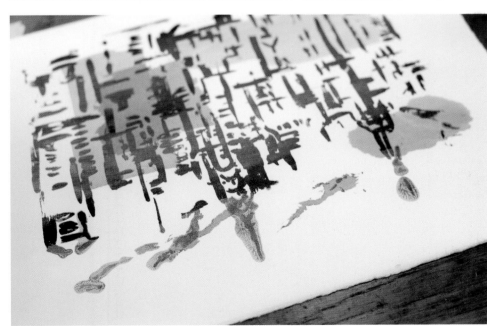

Be careful not to lay down too much
ink on the surface of the mesh or
it might bleed round the edges of
the stencil.

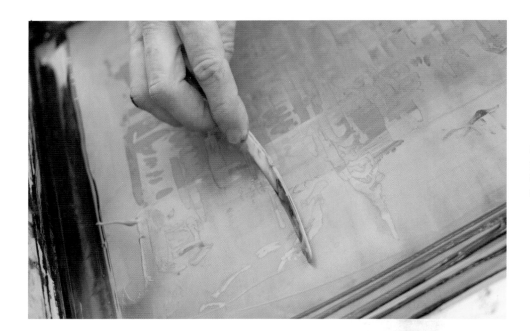

Get used to scraping the edge of the palette knife across the mesh rather than the flat of it so as to allow only a thin smear of ink into the mesh.

Don't forget to put a piece of paper in each time, or your print might end up on the table top.

Cleaning Up

Once you have pulled all your prints, clean up all the ink on the screen and squeegee as usual. Then take the screen to the sink or bath and wash out with very hot water and, if necessary, washing soda or scouring powder or cream. Use a soft scrubbing brush.

USING THE KIT FOR TEXTILES

You can use the kit in much the same way to print textiles. Make sure you use the correct textile printing medium.

The screen does not need a 'snap'. It can sit flat onto the textile, so there is no need to bother with strips of card stuck to the frame.

It is sometimes a good idea to pull the ink through twice to make sure it is strong enough. The angle of the squeegee is not so crucial. It may be easier to have the squeegee less upright. Once the textile ink is dry, iron it on the back with a hot iron for minute or two to make it permanent when washed.

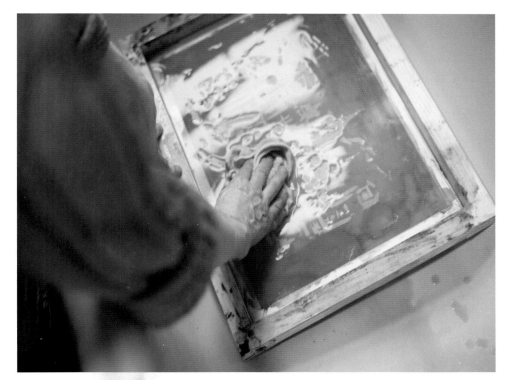

Wash out with hot water.

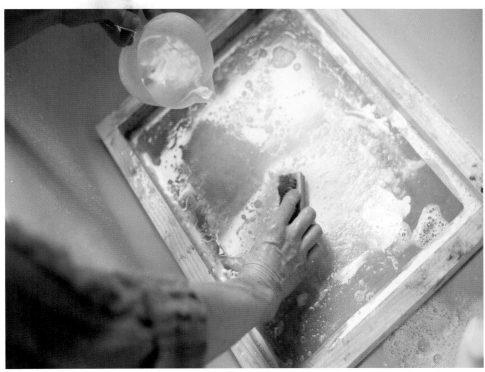

If necessary, use washing soda or
scouring powder or cream. Use a soft
scrubbing brush.

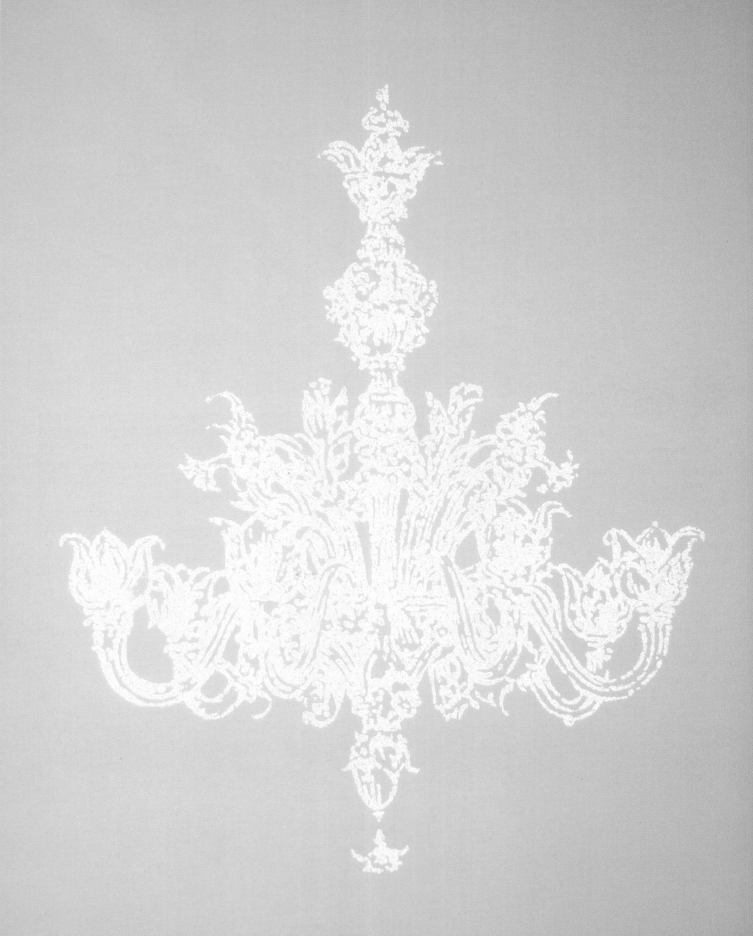

PRESENTATION – SIGNING THE PRINT AND EDITIONING TERMS

Signing the print is always done in pencil. Signature on the right just below the image, edition number on left.

There is a convention for signing prints. Always use a pencil, never a pen; HB or B is preferable. The signature goes on the right just under the right hand side of the image. If there is no room on the front to put the signature, put it either inside the image, or sign on the back. If you have to sign on the back, put the signature on the right there too.

The title, if you want to put one, goes in the middle. This may be put in inverted commas. The edition number goes just under the left edge of the image. It is presented as a fraction, for example: if the edition contains twenty prints number them: 1/20, 2/20, and so on. Prints in an edition should be identical. If they are not identical, but similar, the letters EV can be put next to the edition number to signify that the edition is variable.

AP is an artist's proof and is not part of the edition. These should be no more than 10 per cent of the edition. For example an edition of twenty can have two artist's proofs. If you want to add the year, put it next to the signature.

OPPOSITE PAGE:
Christina Niederberger, *Chandelier*. Light reflecting beads were thrown into the still wet ink.

CLEANING

As mentioned before, it is the hardest job of all to keep everything clean. It is probable that some of your prints will have dirty marks, fingerprints and splashes on the borders of the work. If you are choosing to window mount then most of these dirty marks will be hidden, but if you need to remove them, there are several ways to try. General grubby finger marks will usually disappear with a *soft eraser*.

Acrylic paint is quite hard to remove once dry. But if the mark is only a few hours old it can sometimes be removed by careful dabbing and coaxing with a *damp sponge*. Try not to scrub hard as you may damage the paper surface.

Cuttlefish bone, also called *cuttlebone*, is very handy for removing slightly heavier marks. Cuttlefish (of the Sepiidae family of cephlapods) have a brittle internal structure which we call a bone. These can be found washed up on the beach, especially after a storm. They can also be bought at pet stores as a dietary supplement and beak sharpener for caged birds.

Use it to as a form of sandpaper. Make sure to remove the sharp hard edges of the bone. Find a soft area on the underside and, using much patience and hardly any pressure, very gently and steadily sand down the dirty mark.

Hold the paper up obliquely to the light and you will see it will be slightly roughed up where the cuttlebone has been rasping away, so place a piece of tissue or newsprint over the rough patch and gently, firmly rub across it with the back of your fingernail until the paper appears smooth again.

If the ink mark is quite thick, and especially if it is a small spot or fleck, it can be removed with precise and careful wielding of

Cuttlebone.

Remove any sharp edges. Very gently and patiently sand away the dirty mark.

a sharp scalpel, scratching the blob off. Be careful not to gouge the paper. It may be worth finishing off with a gentle sanding of cuttlebone.

Sometimes it is not worth getting too upset about splashes on the border. With most printed matter produced digitally, it is so easy to obliterate all imperfections; it can be quite pleasing to see a piece of manual labour that shows the human touch, literally.

PRESENTATION

All printmakers have to decide how to exhibit their work. Unlike painters on canvas, works on paper can't just be stuck up on a nail in the wall.

When you planned your image, you also probably planned a border of paper around the printed image to give the work some space and a sense of focus. It is always better to have a frame of a larger size, rather than squashing up close round your work. Give your work the space and respect it deserves.

Framing can get quite expensive. However, there are many very good ready-made frames available.

Works on paper are a bit vulnerable and usually need the protection of glass. Glass should never touch your work, so don't be tempted to sandwich it between glass and board. Paper is sensitive to moisture in the air. If your work is touching the glass, as the ambient temperature fluctuates, the paper may give off moisture. If it is touching the glass, the moisture will condense on the glass and soak back onto the paper. Spores of various microscopic fungi are circulating in the air and will grow in any moisture they find. Over the years this can show as discoloured dots. Look at old prints and you may see this as what we call 'foxing'. The antidote to this is to always maintain a gap between the print and the glass. There are two ways of doing this:

1. WINDOW MOUNTING (ALSO CALLED MAT CUTTING)

Mounting board is available at art shops. Choose an acid-free one for longevity. The mount is meant to display the work at its best and not to distract or detract from it, so, generally stick to white, off-white or soft greys. I would recommend a soft off-white as a general all-purpose mount. Plain white can look fantastic with clear, bright-coloured work. However, a softer white is often more sympathetic. Look for colours called 'Off-white' or 'Parchment' or 'Ivory'. Light and mid-tone greys are also sympathetic and can enhance a rich or many-coloured work.

Keeping clean is essential. Cotton gloves can be worn when handling work, but are a bit clumsy for fine fixing. Get a lint-free cloth for glass cleaning and general dusting, silk is great. Use with methylated spirit or another glass cleaner.

You will need a mount cutter, a sharp knife, ruler, pH neutral tape and a soft eraser. A window mount should be cut with the blade at an angle so that the mount has a bevelled edge. It is very hard to do this freehand with a craft knife. You can buy a mount cutter at art shops. The mount cutter holds the blade at a 45 degree angle. It is advisable to buy the cutter in conjunction with the guide rule. The cutter fits onto the rule and guides the cut line. This is a pretty good way to cut the mount. Be careful that the guide rule doesn't slip causing your line to veer off at a tangent.

If you will be doing a lot of mounting you may want to invest in a full mount cutting kit, also called a 'mat cutter'. This supplies a guide rule fixed to a backing board, to ensure that the rule cannot slip midway through the cut. It may be worth the initial outlay to achieve professional-looking mounts.

Choose the width of your mount to give your image room to breathe, much as you chose the border on the printing paper for your print. It is considered bad visual form to cut the mount right on the edge of your image. Position your image with a centimetre or two of paper showing around the image. Cut the lowest edge slightly deeper so you have room for your signature and so on. Window mounting has the advantage of hiding any dirty marks and mistakes on the borders of your print. For attaching the work to the mount, use archivally sound framers' tape.

2. FLOAT MOUNTING

Work can be 'floated' on a backing board. This simply means, stuck onto a board, but carefully. As there is no window mount to create a space between the work and the glass, a deeper frame must be used, with enough gap to prevent the work touching. 'Box' frames can be purchased and they are a bit more expensive, but they make for easy mounting and give the work that extra space to look good. Alternatively you can buy thin fillets of wood to fix around the inside edge of the frame to create the required gap. These will have to be stuck or pinned in.

If the print covers the entire paper with no border it will have to be float mounted. Likewise, if the paper has a deckle edge it is nice to show it off. We printmakers love our papers and want to show them off to their advantage.

Choose an acid-free backing board. This will probably be the same mounting board that the window mounts are cut from. Firstly, using a soft pencil (a 'B' is good), position the work where desired and lightly mark with the soft pencil (to be erased later when the print is fixed in place). Give it breathing room, and a little more space below looks good.

To be fully archivally correct, self adhesive tapes should not really be used. Purists use strong tissue or thin acid-free paper tape, adhered with starch paste or a dry gum that needs to be moistened in order to stick. These can be removed if necessary without harming the work at a later date. Make life easy for yourself and do as most framers today: use pH neutral self adhesive tape. The whole process is much less tricky.

An efficient and simple way to secure the work to the backing board using pH neutral tape is to cut two thin strips of tape, forming a cross with the sticky sides facing each other, stick them together so only the middle adheres and the arms of the cross are free. Now the sticky sides are opposite each other.

Cut a piece of pH neutral mounting tape. For small works, cut the strip in half to make it narrower.

Place the print onto the backing board.

Make a cross by sticking the pieces sticky-side face to face.

Make sure it is well adhered. Press with a clean cloth.

Place the cross tape at the top corners of the back of the print.

Small works can be adhered by the top only.

Place your work face down on the clean working area. Press the cross shape onto the back of the top corner of the reverse of the work. Rub it down well, but not so hard that it dents the paper. Place another cross in the other top corner. There will still be two arms of the cross with adhesive facing up. Carefully position the work where required on the backing board and firmly rub through to secure the tape cross to the backing board.

Traditionally, paper was only hung from the top edge, as good paper breathes and stretches. If it is stuck all the way around then it may, eventually, cockle a little. But, only sticking it at the top means the print is in danger of flapping around in transit, so most people secure it all round.

Another way to stick the print to the backing board, especially if it is a large work, is by using hinges. Cut a strip of pH neutral tape about 7cm long. Fold it in half so the sticky side is facing out and sharpen the crease. Cut two more strips. These will be used to doubly secure the hinge to the artwork and also to the backing board. Make sure they are tucked well up close to the fold of the hinge.

Another cunning way to float mount is to cut a slit at the top of the backing board just lower than the edge of the artwork and smaller than it so that it won't show from in front. Fix tape hinges to the back of the artwork. Slide these through the slit and stick them from the back. Then seal up the slit in the backing board from behind to prevent it gaping.

WAVY OR COCKLED PAPER

Printing in water-based colours means that sometimes the paper will cockle and become wavy. Some papers are more prone to cockling than others. Many people agonize over this and try flattening it out.

Paper is susceptible to the moisture in the air; it is like a living breathing entity. You should let it breathe. Beautiful handmade papers should be appreciated for what they are – they are not cheap commercial ephemera to be glued flat. Enjoy a bit of gentle undulation in a good printmaking paper.

If it is particularly bad and you really want to try to flatten the work, gently spray the reverse of the print with water from an atomizer. Place it between sheets of acid-free blotting paper beneath boards with a weight on top and leave it overnight or for longer if it is thick paper; change blotting paper for dry sheets the next day. If the artwork has been rolled up in a tube for a while, let it lie out as flat as it can for a while, then place it under boards overnight.

Treat paper with care and respect: it is an integral part of your work.

FURTHER INFORMATION

SCREENPRINTING AND PAPER SUPPLIERS

Daler Rowney
System3 paints and screenprinting mediums, available in most
art shops
Peacock Lane, Bracknell RG12 8SS
+44 (0)1344 461000
www.daler-rowney.com
webmaster@daler-rowney.com

Intaglio Printmaker
Printmaking materials and equipment
9 Playhouse Court, 62 Southwark Bridge Road,
London SE1 0AT
+44 (0)20 7928 2633
http://intaglioprintmaker.com
info@intaglioprintmaker.com

T N Lawrence & Son Ltd
Printmaking materials and equipment
208 Portland Road, Hove, East Sussex BN3 5QT
+44 (0)1273 260260
www.lawrence.co.uk
artbox@lawrence.co.uk

Cadisch
Screenprinting equipment
Unit 2, The IO Centre, Hearle Way, Hatfield, Hertfordshire
AL10 9EW
+44 (0) 208 492 0444
www.cadisch.co.uk
info@cadisch.com

Printall/London Screen Services
Screenprinting equipment
Printall Studios, 42, Raymouth Road, Bermondsey, London
SE16 2DB
+44 (0) 207 232 0363
www.printallstudios.com
info@printallstudios.co.uk

Handprinted Ltd
Screenprinting equipment
22 Arun Business Park, Shripney Road, Bognor Regis PO22 9SX
+44 (0)1243 696789
www.handprinted.net
shop@handprinted.co.uk

Fortune & Associates Limited
Exposure units and portable screen beds
42 West Street, Axbridge, Somerset BS26 2AD
+44 (0) 7973 776019
www.fortuneandassociates.co.uk
fortune.eden@virgin.net

John Purcell Paper
Fine art papers. Screen medium and tinters. True-Grain
15 Rumsey Road, London SW9 0TR
+44 (0)20 7737 5199
www.johnpurcell.net
jpp@johnpurcell.net

R.K.Burt & Company Ltd
Fine art papers
57 Union Street, London SE1 1SG
+44 (0)20 7407 6474
www.rkburt.com
sales@rkburt.co.uk

INDEX